I.E.D.
War in Afghanistan and Iraq

by David Levinthal
text edited by David Stanford

pH powerHouse Books Brooklyn, NY

CONTENT

OSCAR MIKE (On the Move)

This book is an examination of how we are looking at war. It is about how and perhaps why the wars that we are now engaged in have been miniaturized and abstracted right before our eyes.

We are faced for the first time with war that is brought to us virtually in real time, through cell phone images and streaming video, daily television sound bites, and a profusion of milblogs. And it is being brought to us through toys and models as well.

In the fall of 2006, I came across a company that was making sets of model soldiers and civilians from the wars in Iraq and Afghanistan. They were made of metal and beautifully hand-painted.

I had seen one of the first sets of these figures back in 2004—a group of figures depicting Osama bin Laden being captured by U.S. Special Forces. The vacuum-formed cave that served as a background was available as an accessory. Two years later, there was suddenly a flood of figures and models, miniaturizing the participants

and objects involved in both conflicts; everything from Iraqis manning checkpoints to insurgents, who came in a box labeled "The Bad Ones." Along with the increase in the number and type of models came an increase in the quality of the figures and armored vehicles. Kits were now available that offered highly detailed molded plastic parts that could be painted and used to construct extremely realistic dioramas.

Thirty-six years ago, while I was a graduate student in photography at Yale, I started working with some very small and very simple unpainted plastic toy soldiers. Creating primitive dioramas with butcher paper and paint, I began a series of photographs that eventually evolved into a collaboration with fellow student Garry Trudeau and resulted in a book entitled *Hitler Moves East*. First published in 1977, it re-created the conflict of the Eastern Front in WWII.

In the early 70s there were very few documentary photographs or films from the Eastern Front available. The British series on the subject,

narrated by Burt Lancaster and broadcast on PBS in 1978, was appropriately called "The Unknown War."

This paucity of images gave Garry and me a virtually blank visual canvas. I hadn't lived through World War II, so I was free to let my imagination merge with the documentary images that did exist and create a symbolic reality. Working with the concept of staged photography, I was venturing into unbroken ground.

The situation I faced when I began this project in 2007 was completely different. The reality of war today is all too vivid. Not only are there now models covering every facet of the war and every imaginable vehicle, but all of these figures exist in every degree of quality, from the most simple representation to the most complex and exact replica.

Synchronicity has linked my work to a project by my *Hitler Moves East* collaborator, Garry Trudeau, creator of the comic strip Doonesbury. In the fall of 2006 he started The Sandbox, a milblog which posts writing from troops deployed to Iraq and Afghanistan on his website Doonesbury.com. In the course of The Sandbox's first two years the site's Duty Officer, David Stanford, has edited and posted over 500 essays from over 100 contributors. For *I.E.D.* he has drawn from that body of work to provide the boots-on-the-ground testimony that accompanies the images.

What was I trying to accomplish with these photographs? Leaving aside the analysis that psychotherapy might provide, which would be far too expensive and impossible to schedule around the demands of a very active four year old, I can only venture a self-reflective guess. I was drawn to these figures in large part because I was both amazed at their existence and fascinated by what they represent. I wanted to make beautiful, compelling pictures of the horror of war. I wanted to create reality without hiding the unreality of what I was doing.

When something unreal can become almost real, it is perhaps more frightening to us, and perhaps more revealing.

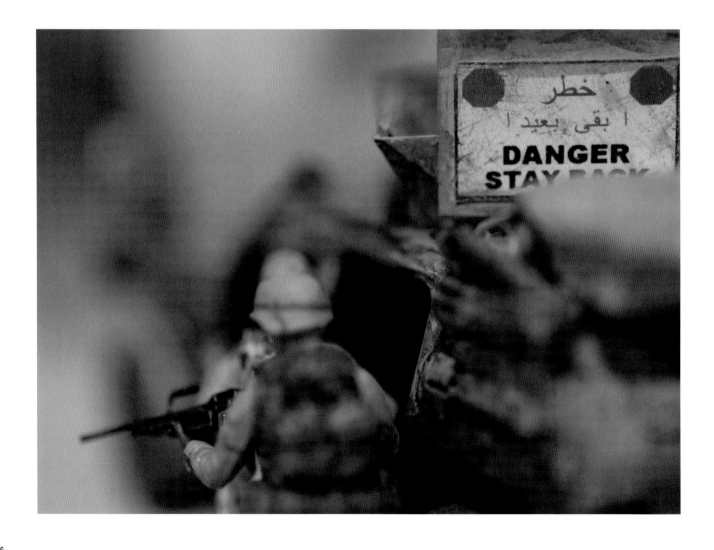

ROE
Rules of Engagement

Our new home combines all the best aspects of living in a coal mine, a bunker, and a ruined city, in one convenient package. We've boarded up and sandbagged all of the windows, since the locals still like to take occasional potshots at us, so except for the gray light that filters down from the central skylight, the interior of the structure is perpetually dark. They handed out cool little LED lights for everyone the other day, which strap right onto your forehead. At any one time there are several hundred multi-colored spheres of light bobbing around in the gloom, and out of that gloom lurch lumbering, hunch-backed troglodytes, bent low beneath the weight of their black weapons and gear; soldiers in body armor moving back and forth on their missions. I'm reminded simultaneously of H.G. Wells and Pogo— "We have met the Morlocks, and they are us."

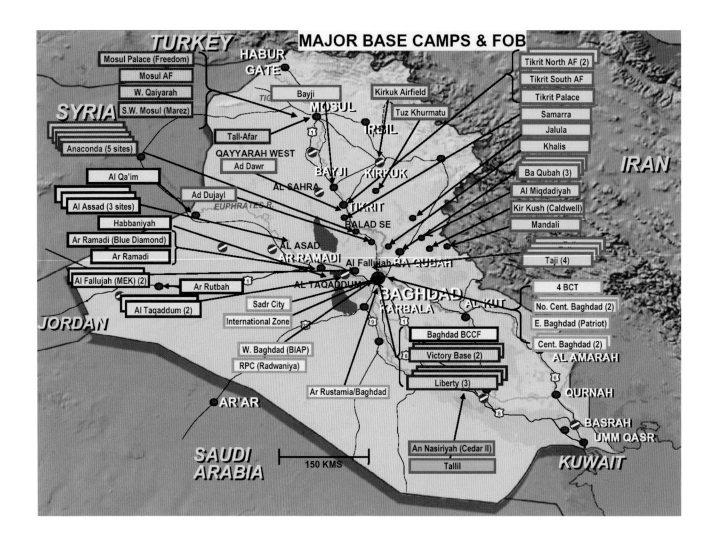

MAJOR BASE CAMPS & FOB

TURKEY

SYRIA

JORDAN

SAUDI ARABIA

IRAN

KUWAIT

Mosul Palace (Freedom)
Mosul AF
W. Qaiyarah
S.W. Mosul (Marez)
Anaconda (5 sites)
Al Qa'im
Al Assad (3 sites)
Habbaniyah
Ar Ramadi (Blue Diamond)
Ar Ramadi
Al Fallujah (MEK) (2)
Al Taqaddum (2)

Tall-Afar
QAYYARAH WEST
Ad Dawr
Ad Dujayl
Ar Rutbah
Sadr City
International Zone
W. Baghdad (BIAP)
RPC (Radwaniya)
Ar Rustamia/Baghdad

Bayji
Kirkuk Airfield
Tuz Khurmatu

Tikrit North AF (2)
Tikrit South AF
Tikrit Palace
Samarra
Jalula
Khalis
Ba Qubah (3)
Al Miqdadiyah
Kir Kush (Caldwell)
Mandali
Taji (4)
4 BCT
No. Cent. Baghdad (2)
E. Baghdad (Patriot)
Cent. Baghdad (2)

Baghdad BCCF
Victory Base (2)
Liberty (3)
An Nasiriyah (Cedar II)
Tallil

MOSUL
IRBIL
BAYJI
KIRKUK
AL SAHRA
TIKRIT
BALAD SE
AL ASAD
AR RAMADI
Al Fallujah BA QUBAH
AL TAQADDUM
BAGHDAD
KARBALA
AL KUT
AL AMARAH
QURNAH
BASRAH
UMM QASR
AR'AR

EUPHRATES R.
TIG

150 KMS

The first time I got blown up, I had to remind myself to get up and look around for the trigger man, or possible gunmen, set to take advantage of the confusion. I felt like I was floating through a world where time stood still. There's something about looking directly at an artillery shell, and seeing it vanish with a sharp crack and a rush of dust and debris, that changes you. My brain was yelling at me, "This isn't normal! You shouldn't be alive and thinking right now!" and my body was yelling back, "Well, I'm definitely alive, so hoist your doubting ass up into the turret!"

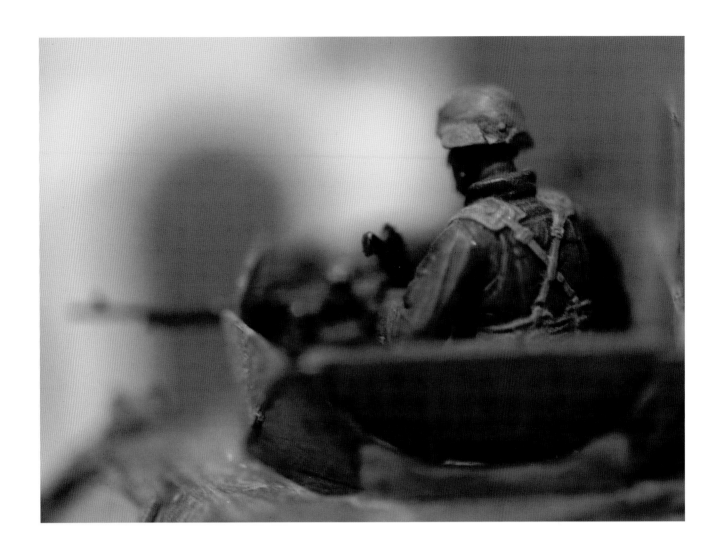

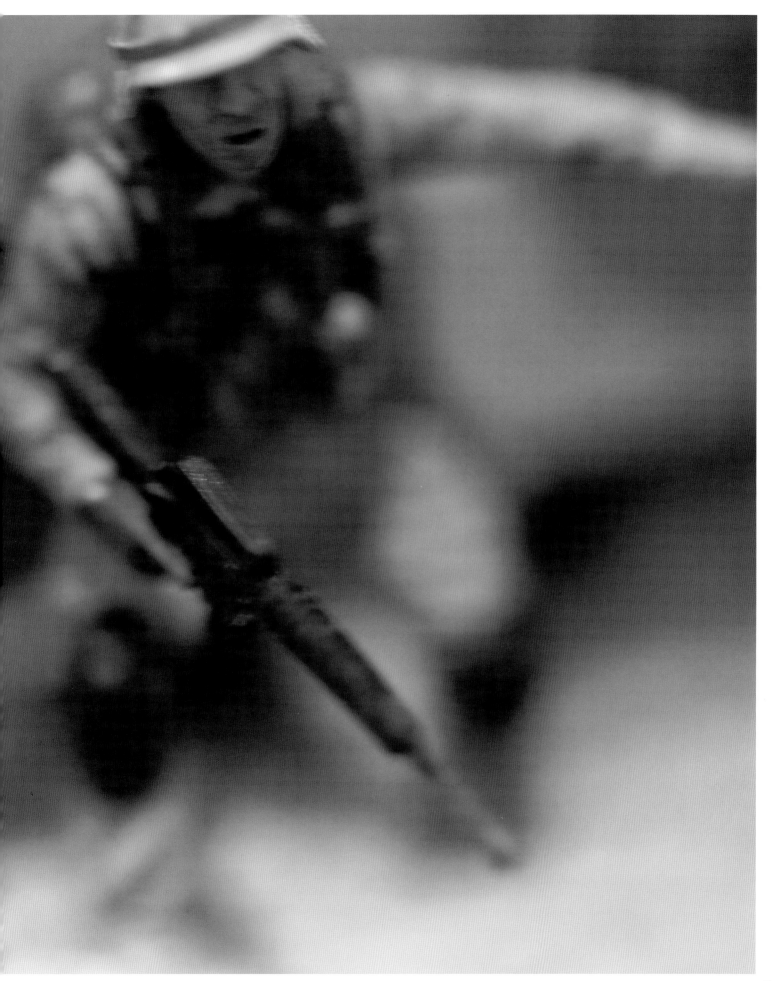

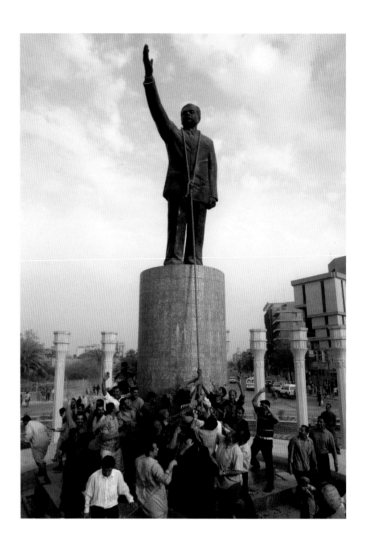

Recently, as I was in the open rear-facing seat of a humvee, fighting started up at the front of the convoy. We were towards the back and couldn't see the engagement in front of us, and weren't taking any fire from the left, where it started from. Within a short time, I start hearing zzziip, zzziip. I look around in confusion, because I didn't hear any shots. The zips continue, and I still don't hear anything, so I yell to the guy up front, "Hey Larry, I think someone's shooting at me." It sounded so ridiculous I still want to laugh about it, but I didn't at the time because we figured out where it was coming from when the truck behind us got raked down its right side.

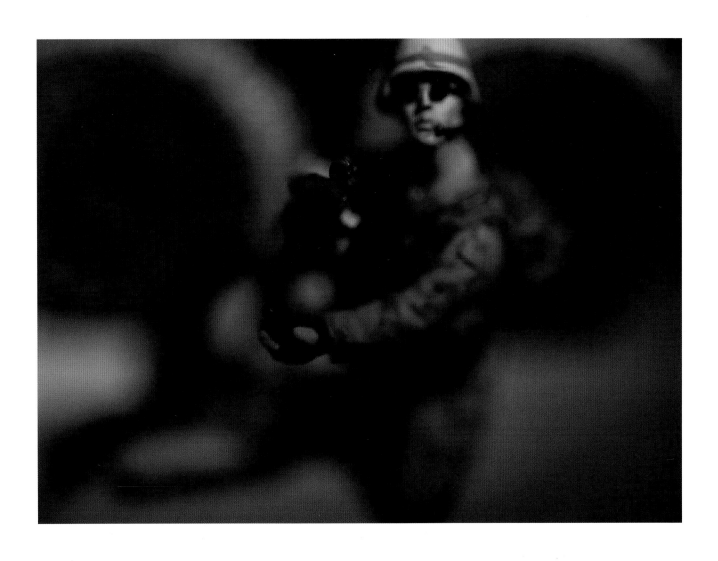

You never once get a positive ID on the bad guys, on where the triggerman is, or where the small amount of AK or PKM fire is coming from—just enough fire to piss you off, but not enough to let you pinpoint where they are. Just one of those times I wish I could have seen a muzzle flash or somebody with a weapon so it would not have been only a one-way live firing range but a two-way. I didn't come here feeling that strongly about this, but when you take enough sucker punches from cowards who hit you and run, you wish the bad guys would stick around just long enough for you to get eyes on them and return fire. But that's the way these wars are. At times it feels like we're fighting ghosts.

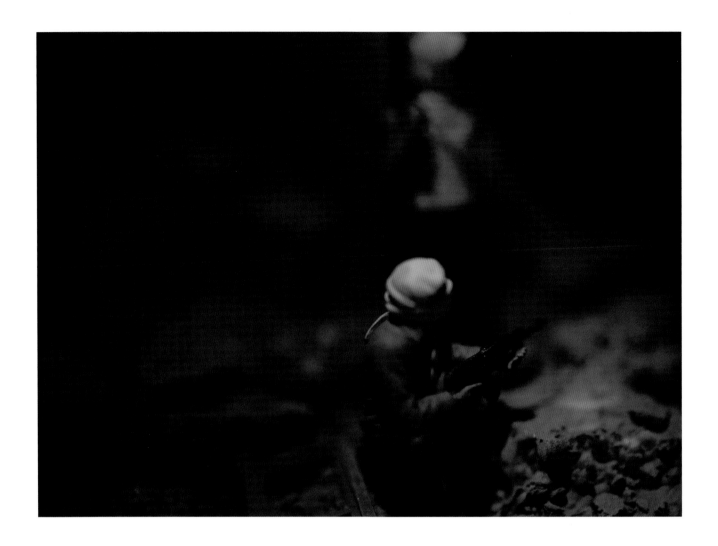

This is my first deployment to Iraq, and I am not afraid to say that I am scared to death every time we leave the wire. We got hit with an IED about three weeks ago. The powers that be "grounded" me for three days. Since I started going back on patrol, I have noticed that my nerves are more unsettled than they have ever been. Every time we go out, I know there is a chance we may get hit or shot at. I accept that. That is part of my job. No, my duty.

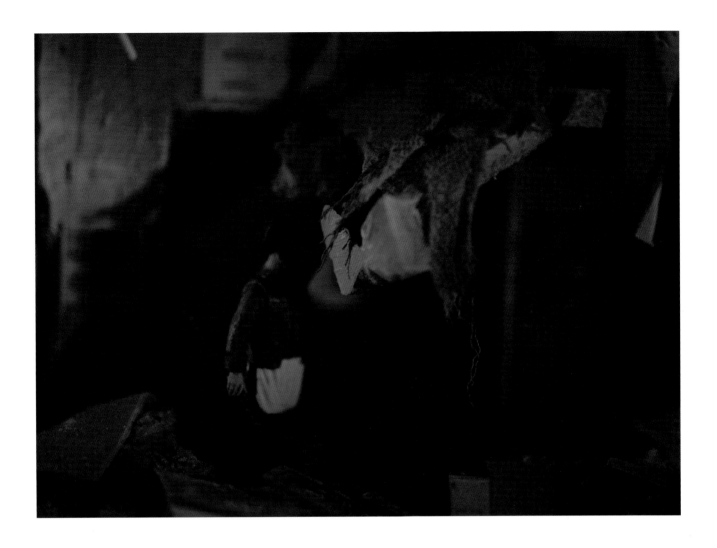

We finally blew the IED, and almost immediately after, the dozens of kids who were begging for handouts before started yelling, "Thank you! Thank you!" and, "Very good." It felt kind of good for a bit. Though the adults around didn't vocalize it like the kids, I hope they felt the same way. I guess they were probably not too happy with bombs being planted in their neighborhood and were glad to see us get rid of this one, even if it was meant for us. We're happy too, as long as we are finding these IEDs or the locals keep reporting them to us before they go off underneath one of our trucks.

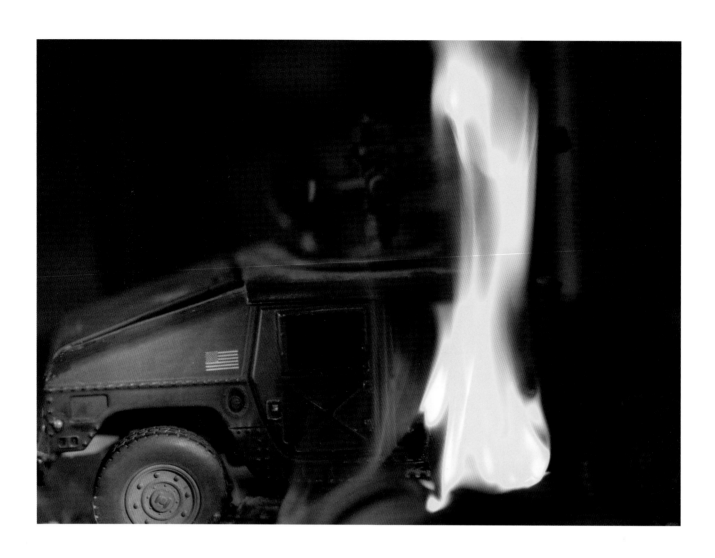

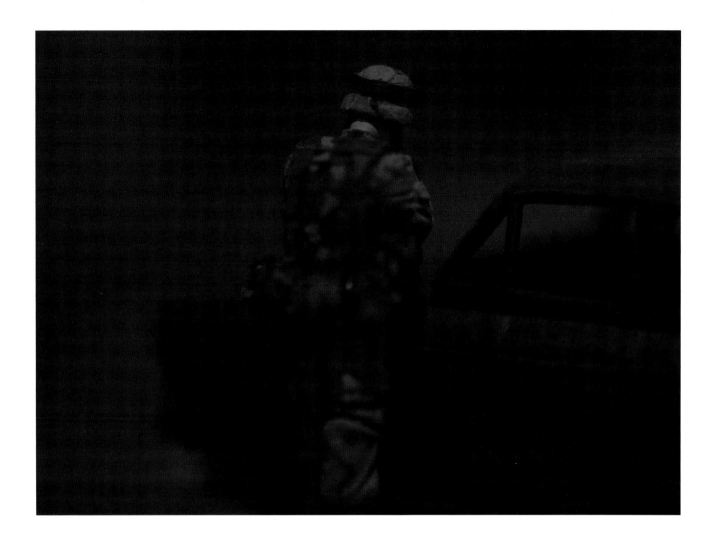

Turning around, I scan the low hulking shadows of the houses across No Man's Land for any sudden muzzle flashes that would indicate the shooter's position. There is a gun battle going on, no more than 400 meters from the Alamo. The sky and the buildings to the north remain dark. To my left, one of the soldiers, a young private, flips down his night vision and scans the darkness of an alleyway for movement. He is fidgeting nervously from foot to foot. Anybody could be out there tonight.

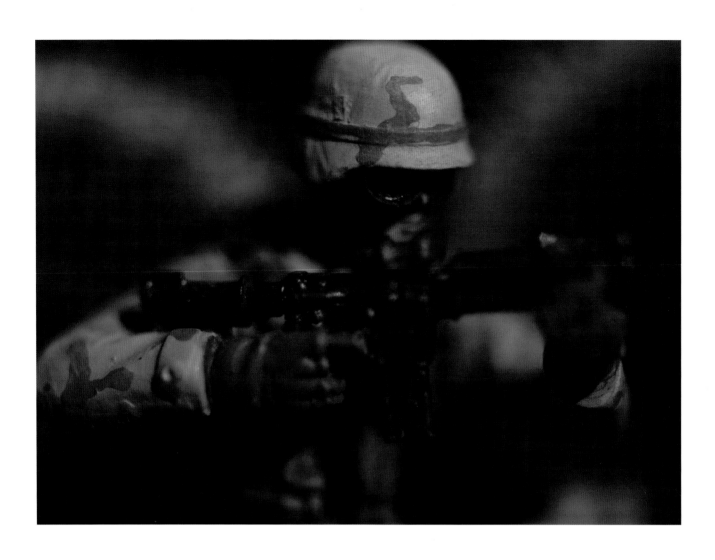

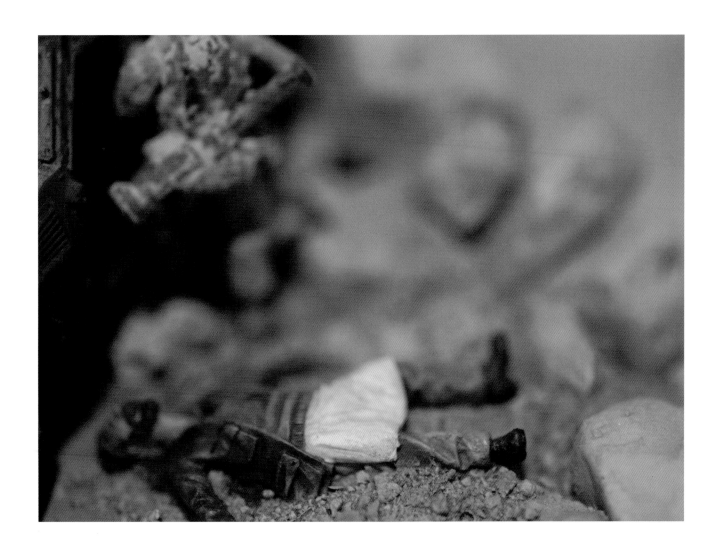

This guy was looking at me with fear in his eyes,
expecting me to finish him off. When he realized
I was trying to stop his bleeding, he relaxed and
put his hand over his heart.

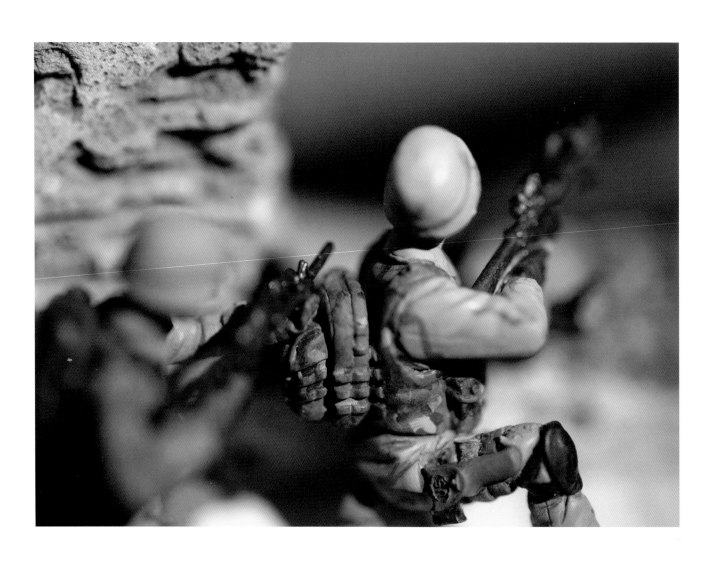

BOOTS ON THE GROUND

I flipped the selector switch on my M4 from safe to burst, put the weapon to my shoulder, and unloaded over the rooftops. Muzzle flash, strobing. Glint of sunlight on ejecting brass. The reassuring push of the stock in the hollow of my shoulder as the three-round bursts kicked out. Someone was screaming at the top of their lungs—"BRING IT MOTHERFUUUUCKERS" —and I dimly realized, somewhere in the back of my skull, that it was me.

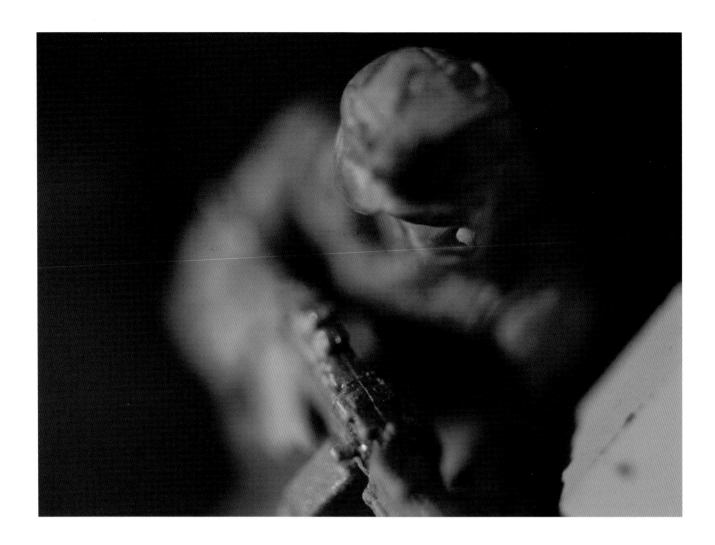

More rounds began to explode on the bank and in the grass; the trucks in front of us caught the exhaust from the mortar tube and began to pour machine-gun fire across the river. Somewhere behind us, Bradleys opened up with the whoomp-whoomp-whoomp of 25mm chain gun fire. Bullets flew both ways across the water, glinting and sparkling when shots dipped too low and caught the ripples, then abruptly ceased coming from the far side.

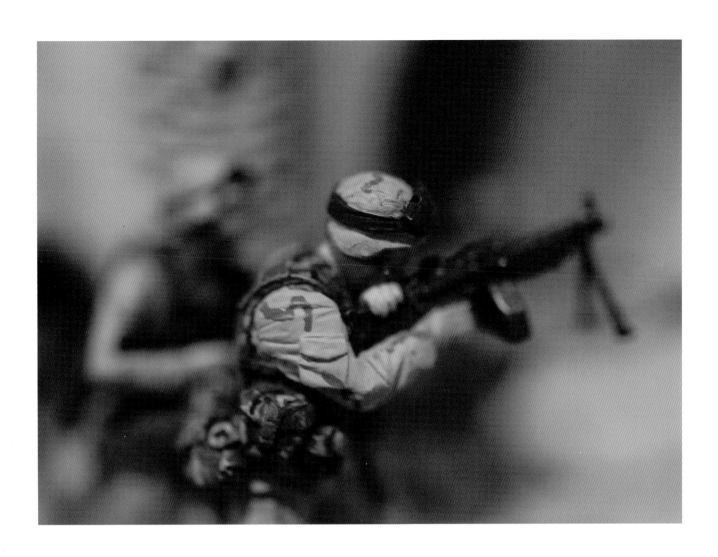

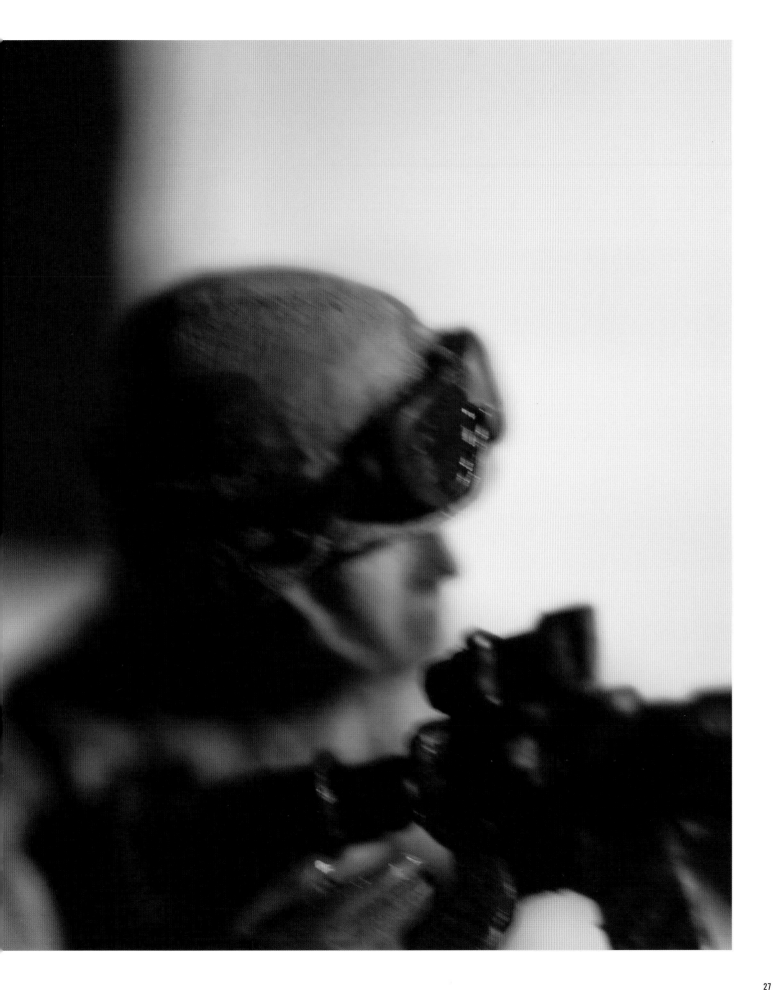

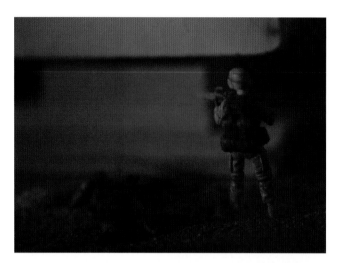

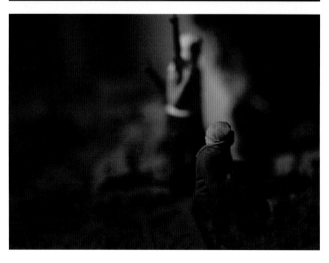

Without electricity, there isn't a whole lot to do when you're not out on mission. Books have enjoyed a sudden rise in popularity, along with chess sets and cards. You start keeping farmer's hours, which means once it gets dark everyone who's not on mission goes to sleep, as if on cue. It's interesting to think that the entire Western world is one flick of a switch away from the Middle Ages.

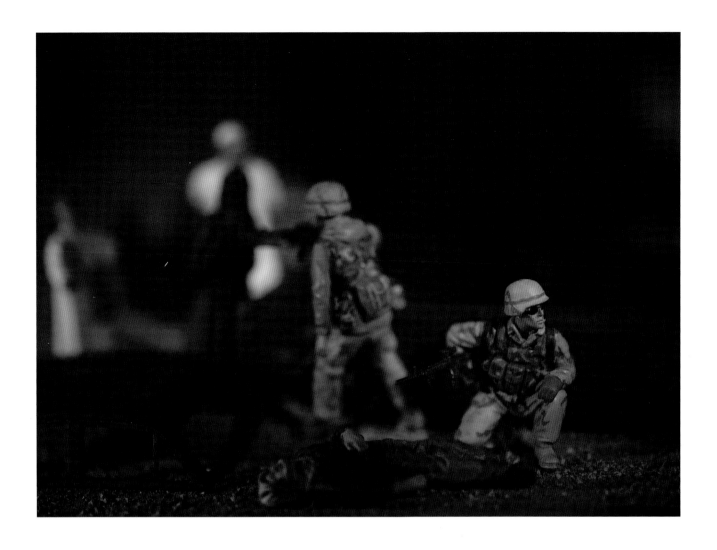

You could hear the retort of our powerful artillery guns fire. It made you want to cheer, and in fact some did, to hear the actual projectile whistle overhead. And then a large explosion as our rounds impacted in the area the insurgents had fired from. It's a sad day when men wish death upon other men, but that is the nature of war. Men put aside some measure of empathy when we are being shot at. Not all empathy, but some. You hear the rounds explode and you hope that they kill whoever just tried to kill you.

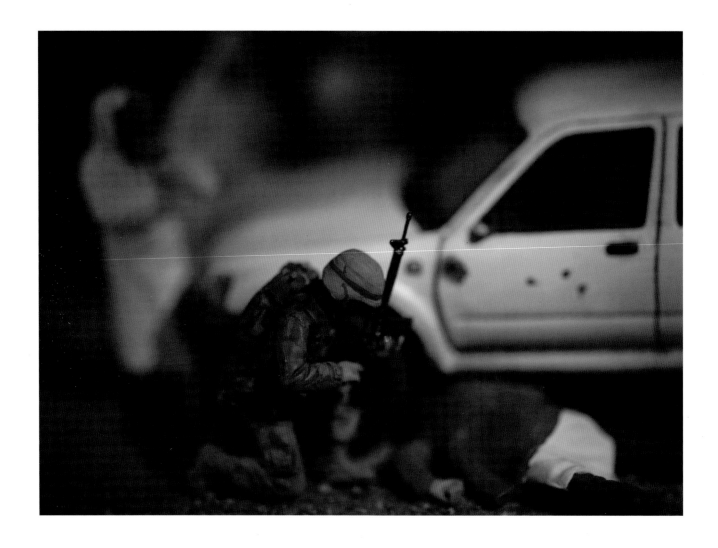

I was the last guy, and just as I was almost across the road I see this car coming towards us. It wasn't going too fast, but I thought to myself, "This guy had better stop." Once he was close enough, I could see in the car, and the driver totally was not paying attention. It now was lining up to where his car and my body were on a collision course. Then, still without looking, the guy hits the gas and starts flying directly at me. Without hesitation, I bring my rifle up to my shoulder, pointing directly at the driver, and I yell at the top of my lungs, "HOLD THE FUCK UP!!"

Killing is not natural to sane people, no matter how often it has happened over eons. There are many ways that you can reconcile yourself in some way to the idea of killing another human. You can think of it as duty—you have a job, and that job requires violence. You can hate—the easiest of all excuses, and the most exhausting. You can look at it as simple survival —if you don't kill him, then he'll kill you. However you justify it, you are still in a war, and people will still die. It wears on everyone—the American deaths, the "collateral damage" we inflict on people in the wrong place at the wrong time, the innocents killed when some faceless murderer blows himself up in a crowd. Yes, even the enemy dead take their toll.

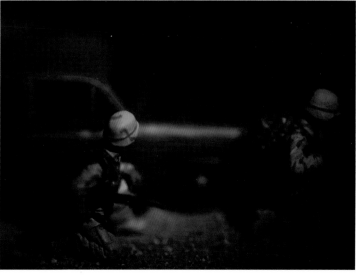

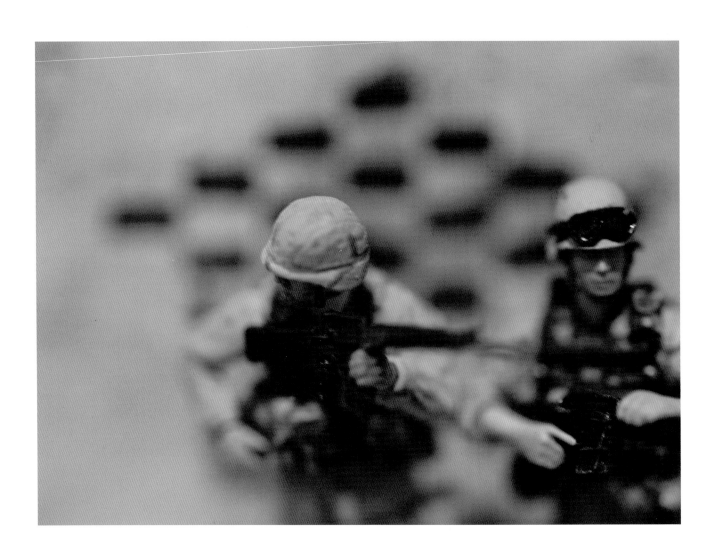

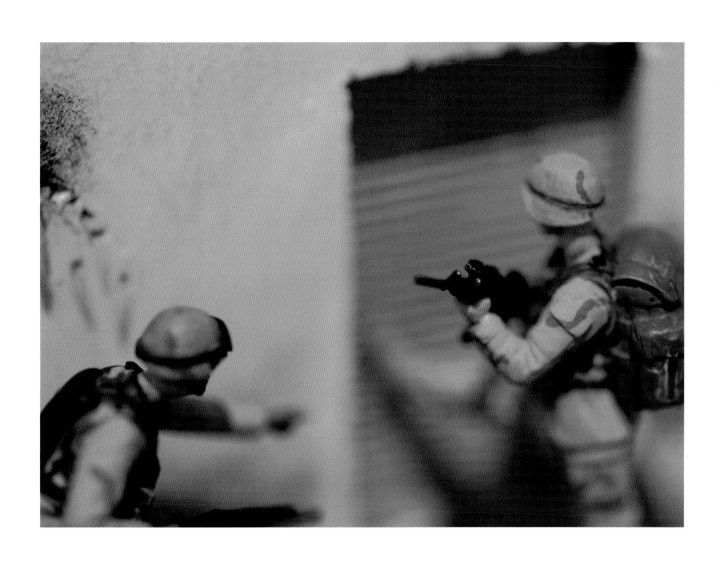

If the sky was dreary and grim today, the city was worse. Nothing moved among the gaunt shells of buildings, save a few tatters of refuse lifted by the breeze. Not even the prowling packs of dogs ventured out of whatever holes they call home. As I stood and looked about, a gust caught the ash from my cigarette and tossed it away. The fire quickly dimmed, and a few more specks of grey drifted down to meet Iraq.

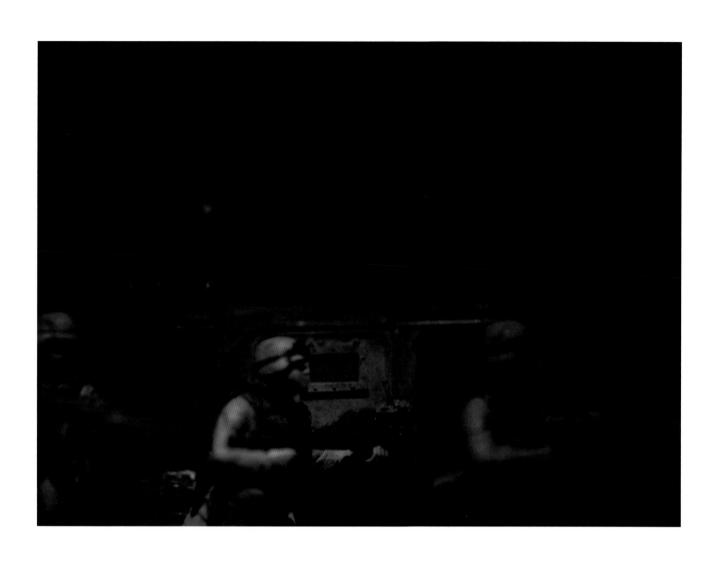

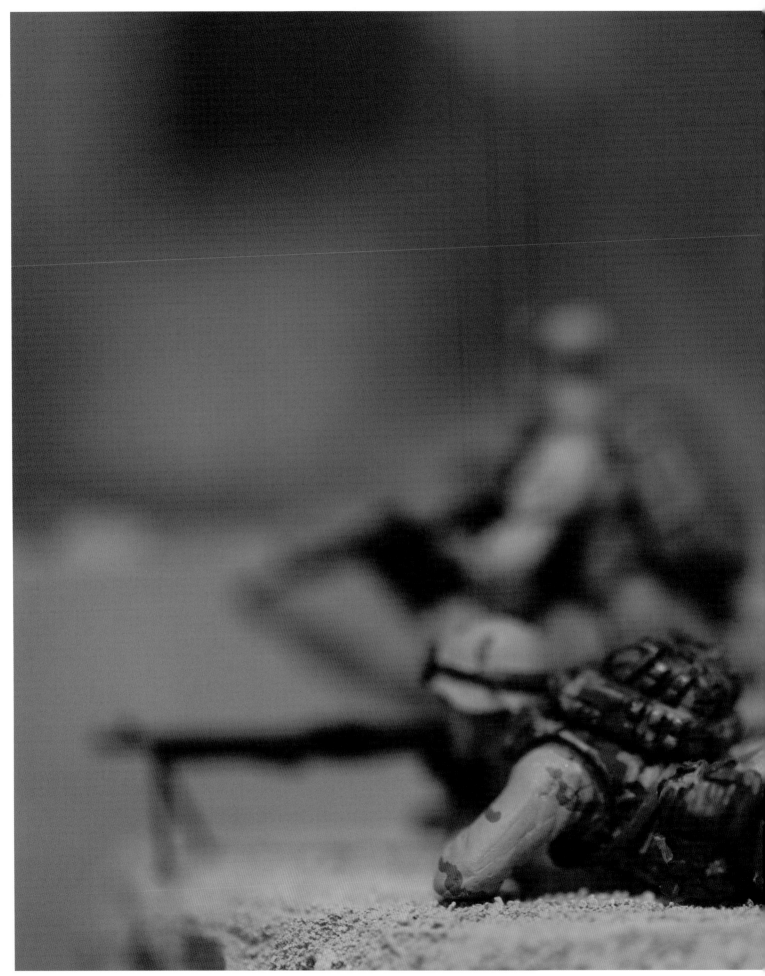

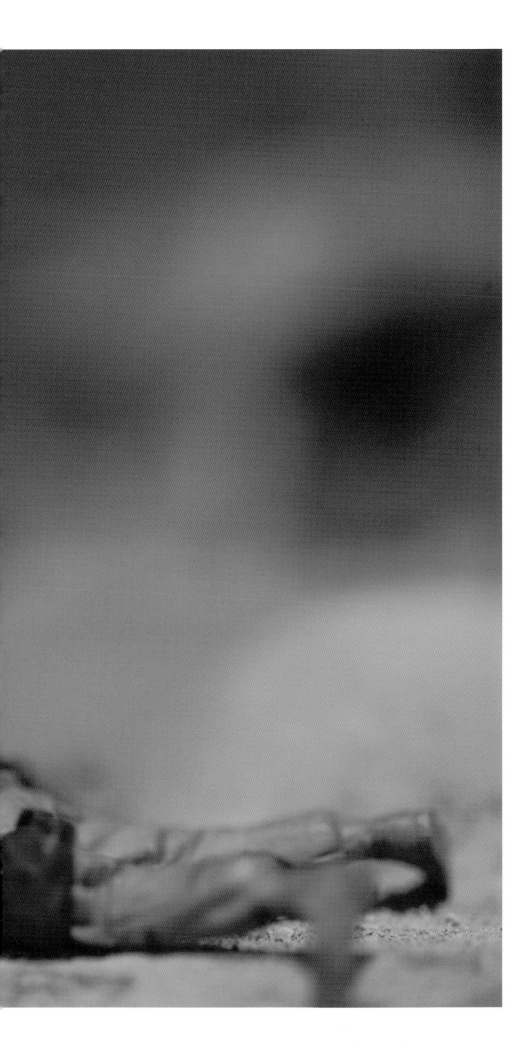

2300 ZULU

I hop up into the turret and start scanning for Anti-Iraqi Forces (AIF, or insurgents), who don't like Marines. The very beginning of a security halt such as this one is exciting. Your body expects something to happen, and all your senses twinge at the slightest hint of the enemy. As the night progresses without incident you slowly lose the initial anticipation, until the only thing keeping you in the moment is the mission, and the knowledge that other soldiers and Marines are out there depending on you.

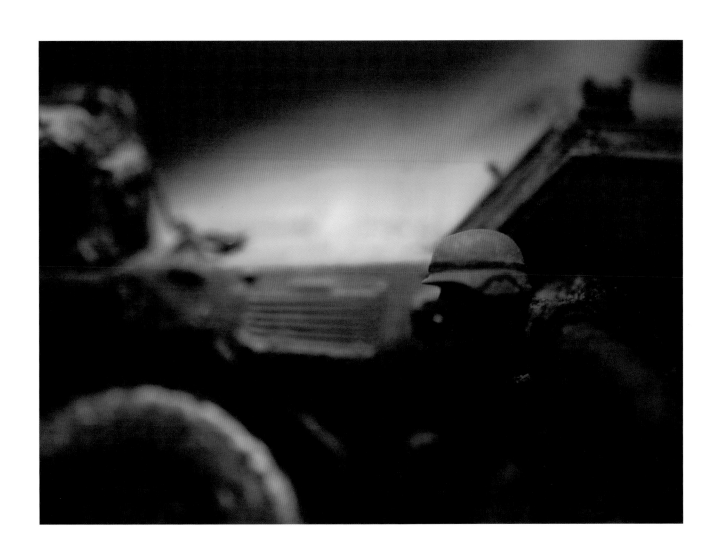

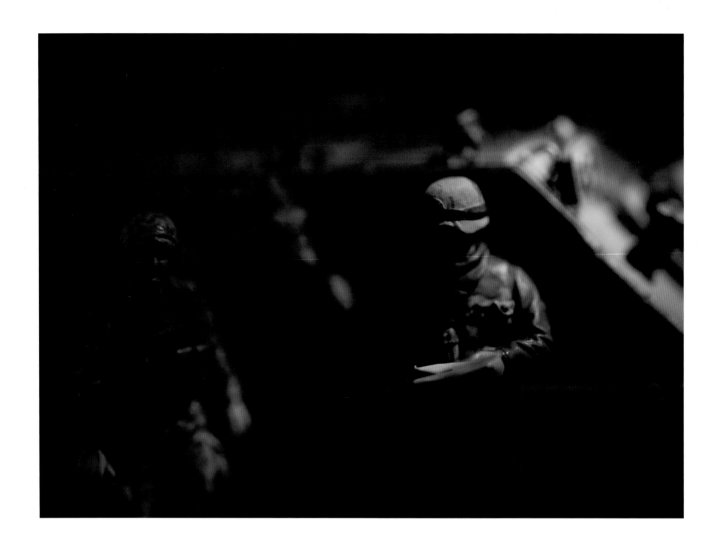

A feared siren bleats
Soldiers run and shout for help,
The air comes alive.

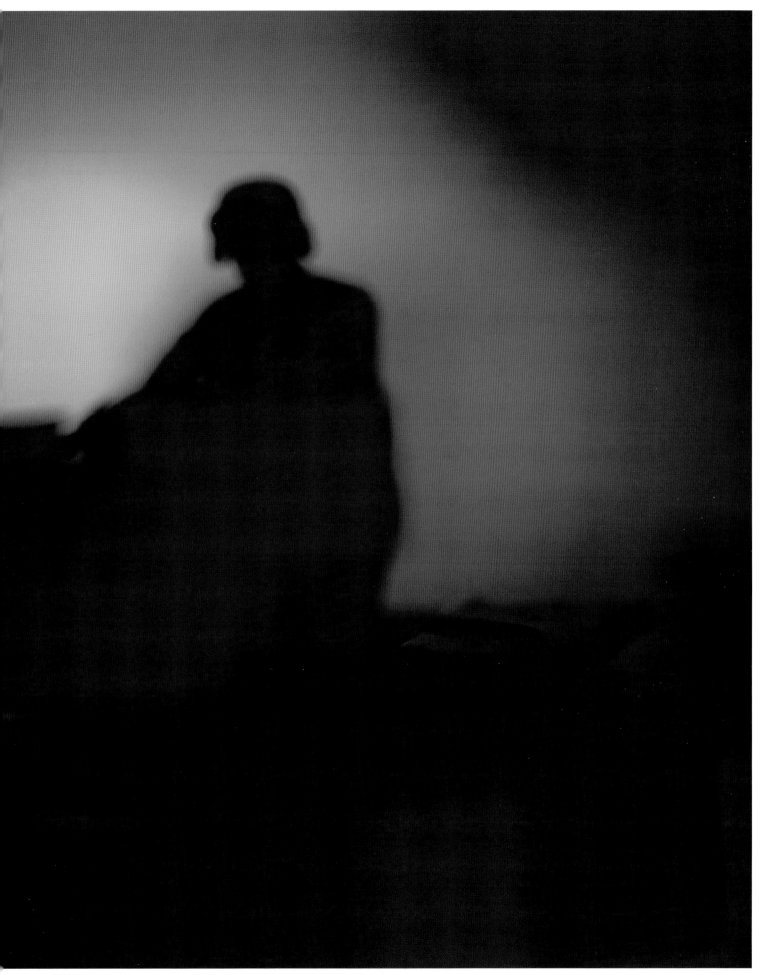

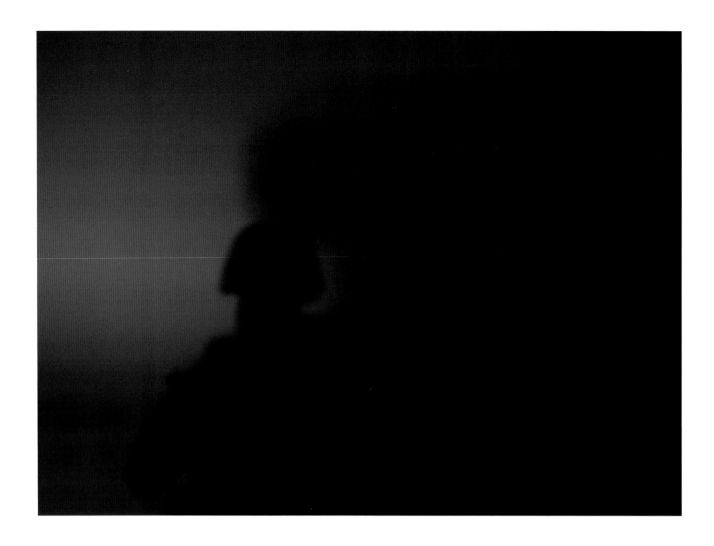

Just past the checkpoint we cross an intersection
covered in brass shell casings of all calibers. Obviously
there was a pretty big firefight here recently. And then
I remember the gun battle we heard from the IP
station. A quick check and it is confirmed that this
is the place, and that there is still fighting going
on in the area. We can't hear any gunfire, but the
sudden emptiness of that long space is more than
slightly unnerving.

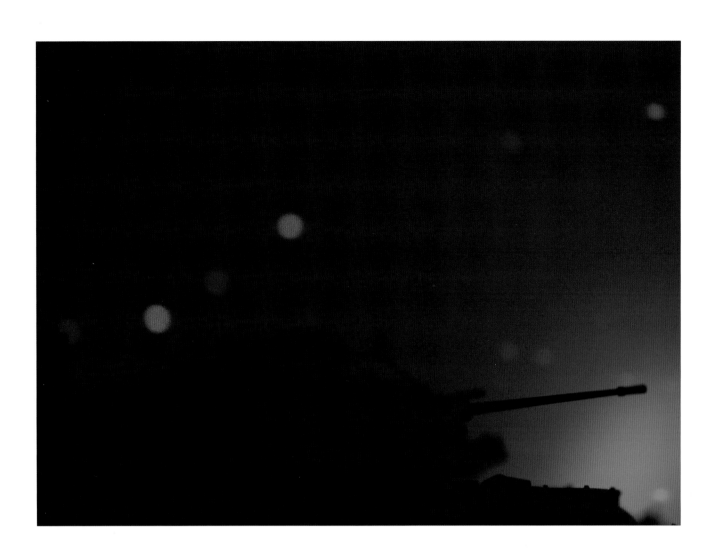

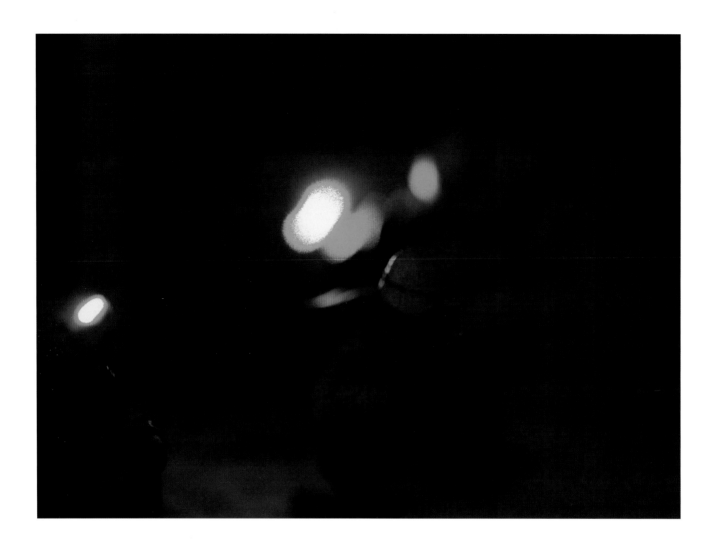

(Audio is disrupted by a large near-miss explosion of an RPG aimed at the HUMVEE.)

Krow: "Goddammit!!!!!!!!!"

Ski: "Yo, I'm getting the fuck out of here!"

Ski: "You want me to go forwards?"

Krow: "You need to either go backwards or forwards!!!!"

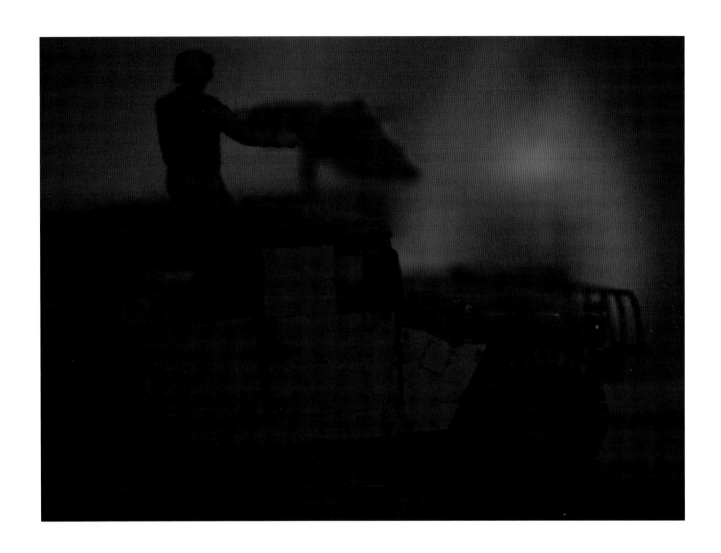

(Vehicle starts moving forward.)

Castro: "Right here."

Krow: "STOP!!!!!!"

Castro: "You got a clear shot? Go for it!"

(Long bursts of 240 machine gun fire.)

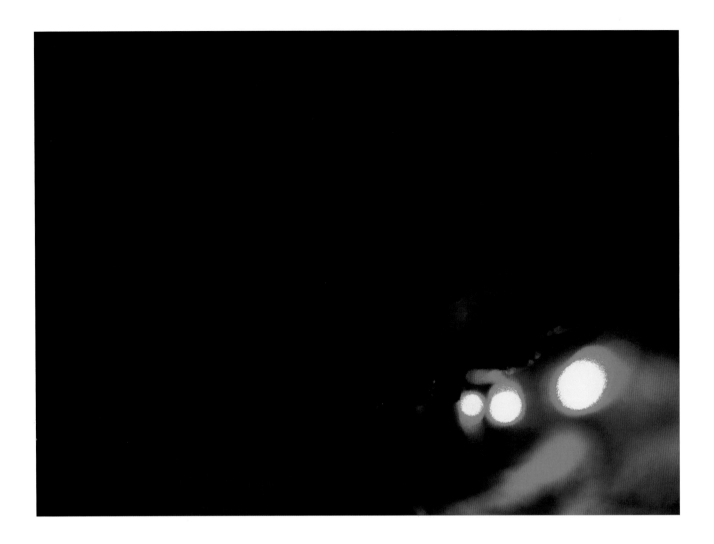

The mortar hit a building with a solid roof, and thus exploded 15 feet above the ground. If it had hit at ground level it could have been a very bad day for the five of us sitting there. But once again, luck or fate or whatever intervened, and we escaped totally unharmed with a crazy story to tell. That's how it is. If it doesn't kill you or hurt you it makes a great story. The question is, how many great stories until it becomes a horrible story? And with war, you just never know.

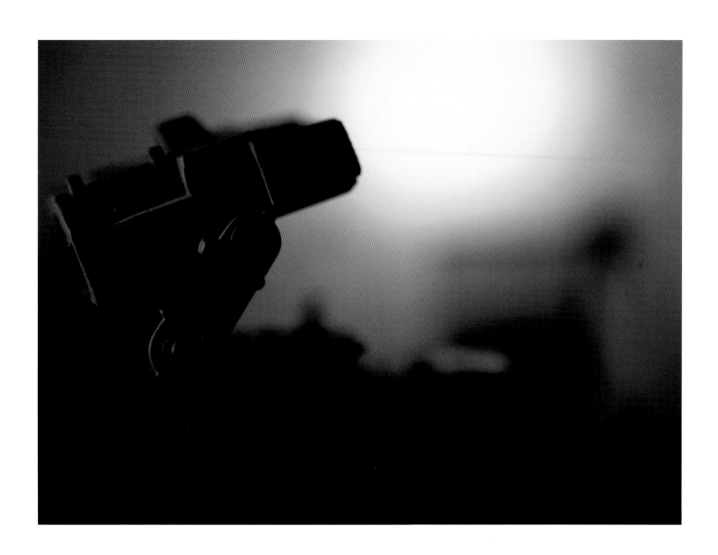

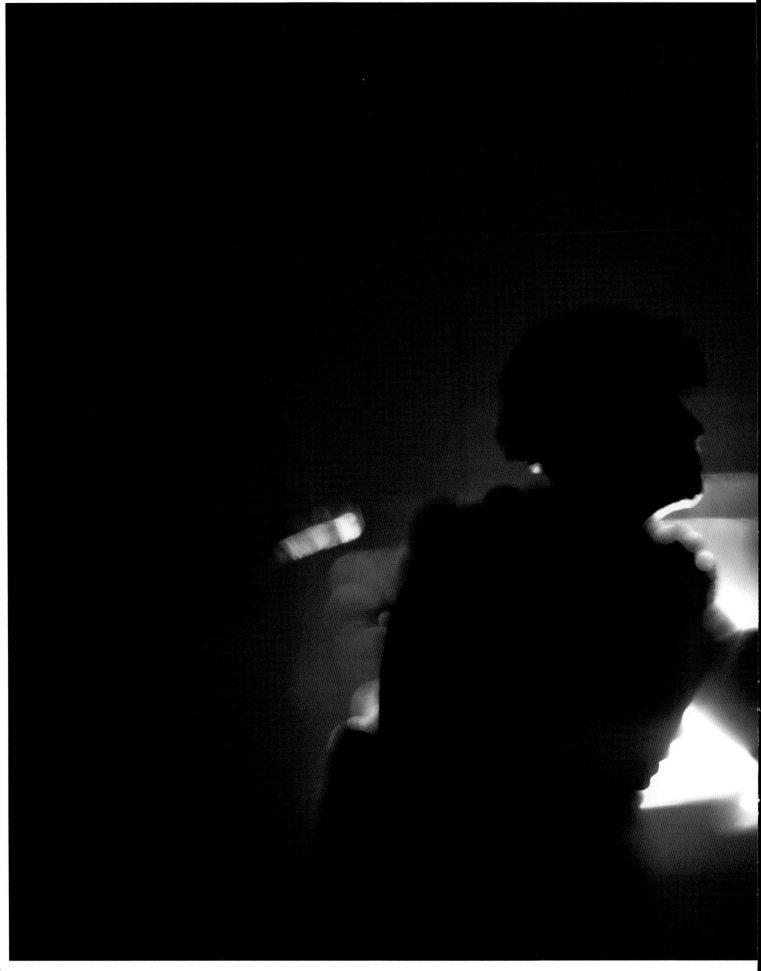

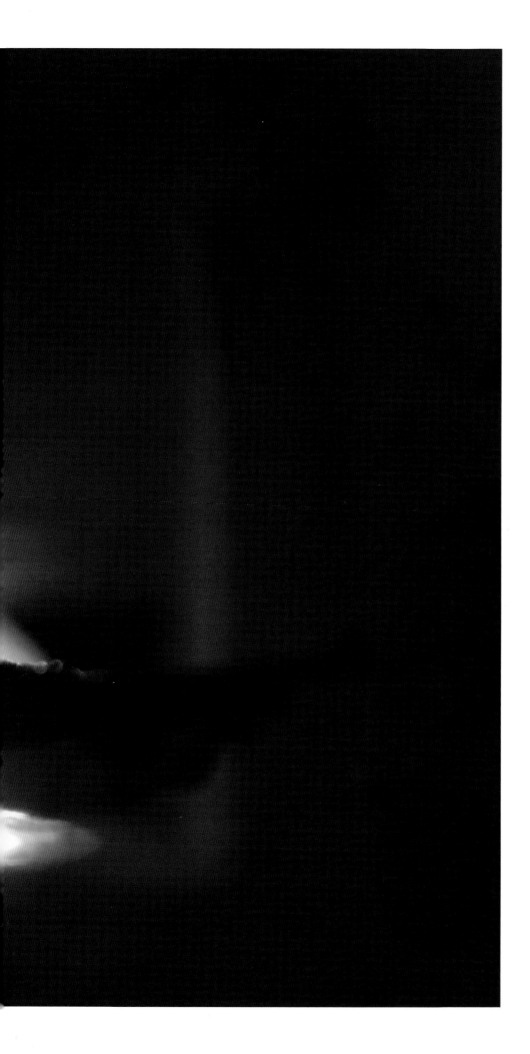

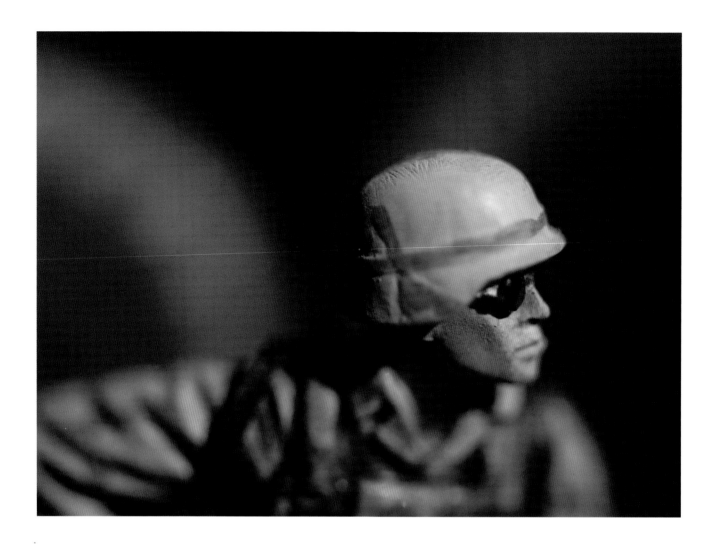

Every time I'm out, my mind runs through the
hundreds of possible ways we could be hit; from that
building over there, from that rooftop on that side,
from the mountains and hills on both sides, from that
car driving up to us, or that person lurking around our
group. I look for kids. I look for things in the road.
I watch for motorcycles with people wearing things
that look too baggy, because the only fat Afghan is a
wealthy one, and he's not going to be blowing himself
up. Your senses become heightened and you're ready
at any given moment for something to happen. You
expect it. You think of countless ways the enemy
could ambush, attack, or approach you.

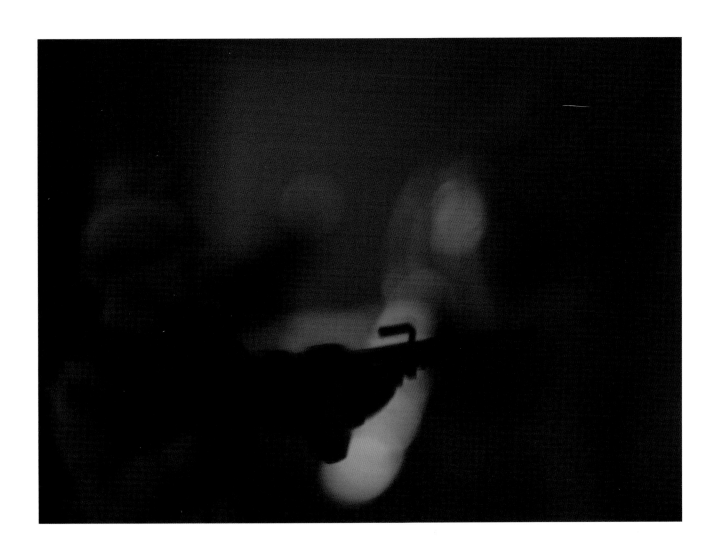

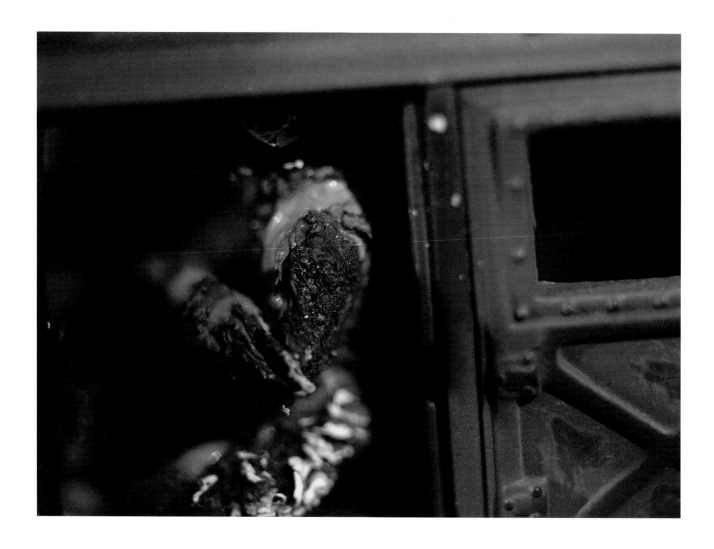

In some parts of Iraq, most of the sprawling garbage is composed of old plastic bottles. Some places, the average IED has a few one-liter bottles full of diesel fuel attached. The "accelerant," as the military calls it, doesn't usually make the bomb more deadly, but it sure becomes a hell of a lot more impressive. Less like fireworks, but less fun to encounter, were the one-liter bottles straddling artillery shells and filled with pesticide. We started wearing Nomex jumpsuits just in case, so the Army-issue brand new polyester-blend ACUs we went to Iraq in wouldn't melt to our skin if one of those impressive fireballs engulfed the truck.

IED

Whenever I'm talking to someone outside of my unit, the conversation always follows roughly the same pattern: They ask what I do, I tell them route clearance, they give me a quick glance to see if I seem okay in the head (like I asked for this job!), and then they tell me what a great job we're doing and how much they appreciate our efforts. Translation: "I'm sure glad it's you and not me, bro." It's one thing to go outside the wire hoping you won't be blown up. It's a completely different matter when you leave expecting to be blown up.

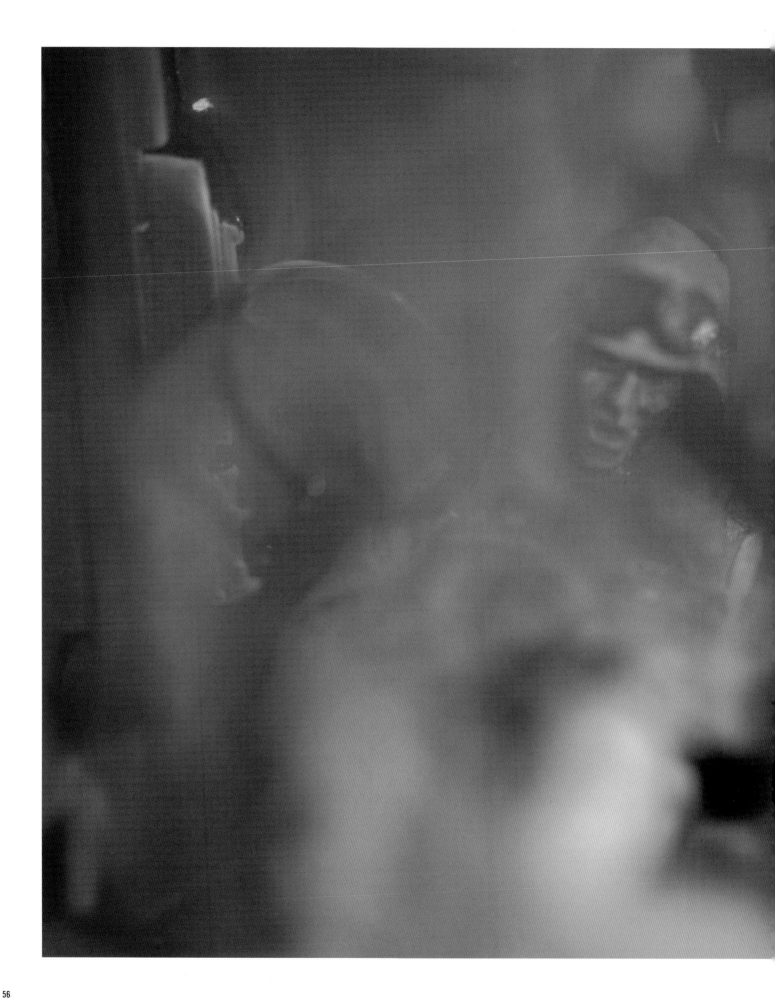

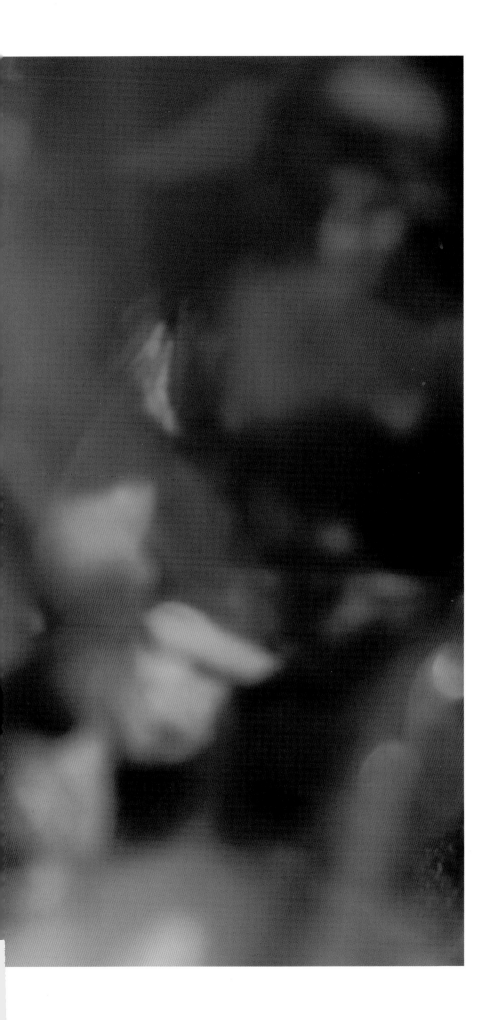

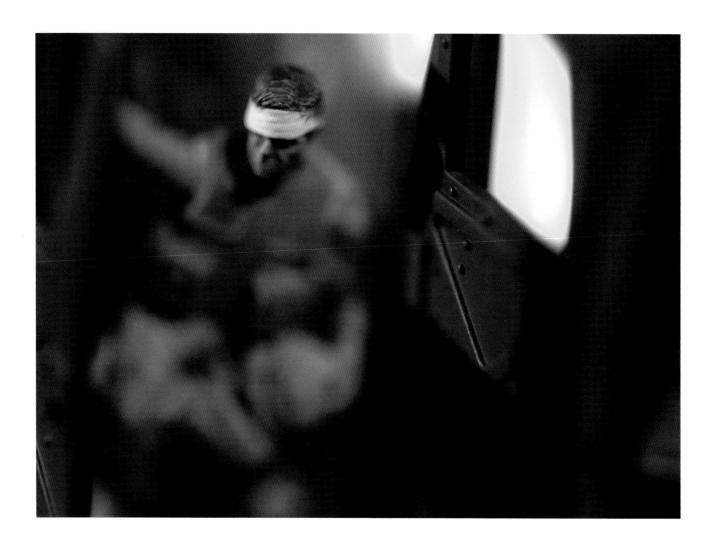

Any vehicle parked along the road could be a suicide bomber. It might suddenly pull out, try to pull up alongside, and blow up. We look for new piles of rubble, or a rock that wasn't there the day before. That's like saying you look for new leaves on the ground in October. We go as fast as possible, passing the endless lines of slow-moving trucks that impede our progress. Each time traffic slows, we look at the faces of all the people around us. Anyone look like they have a vest of explosives on them? Anyone coming nearer than they should? Here's a chokepoint, look around, anything new here? We hit the speed bumps as fast as we can without destroying our vehicle.

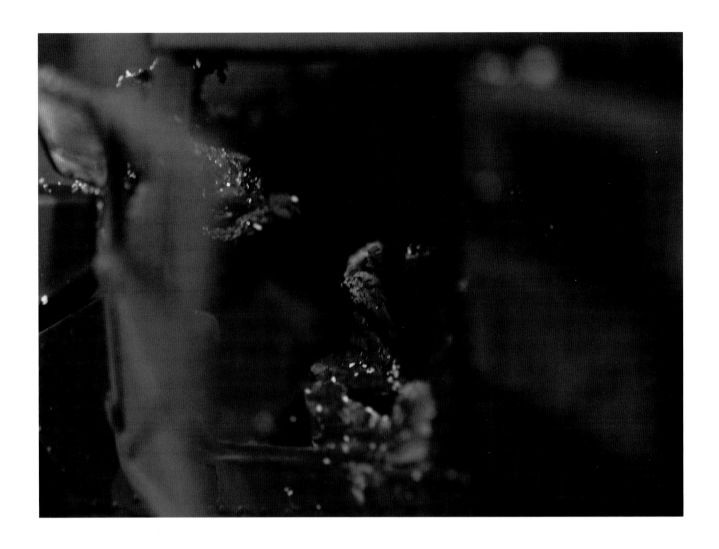

KA-WHAAAAAAAM!!!!!!! I just happened to be looking right at the patch of road to the left of our lead vehicle when it erupted in a pillar of brown dust and gray smoke, accented with a smattering of dull yellow sparks. My electronic headphones cut off the initial sharp hammerstrike of the exploding bomb, just as they are supposed to, but it didn't matter, as the concussion from the blast hit our truck a micro-second later, jarring the HMMWV's boxy six-ton frame, forcing an expletive out of my lungs.

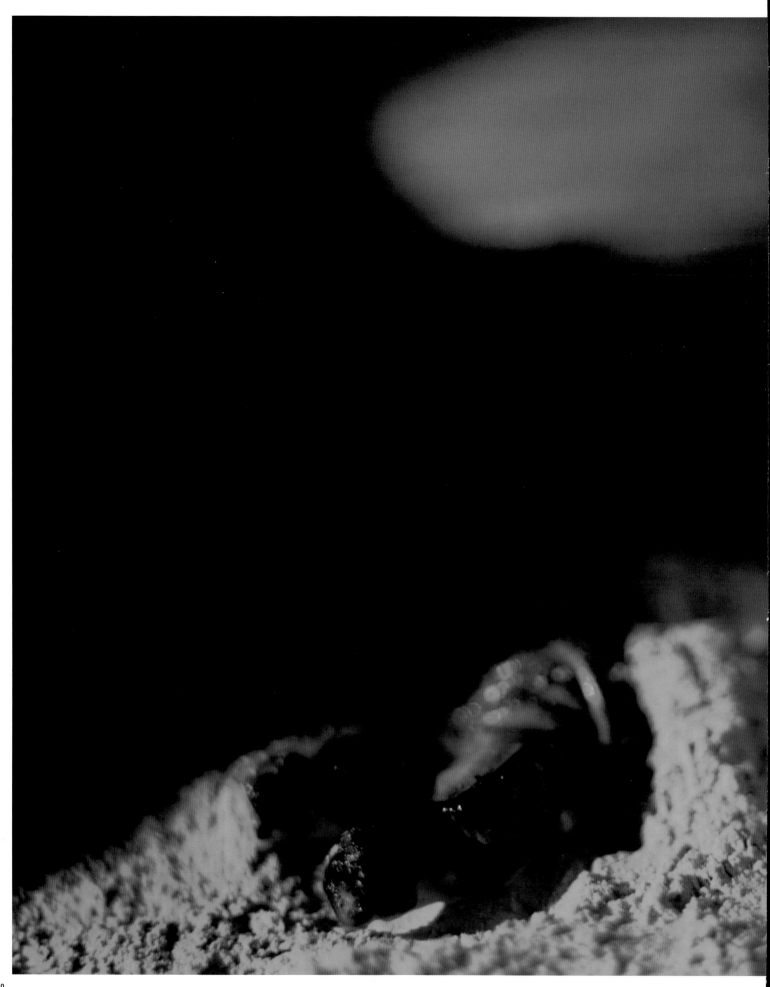

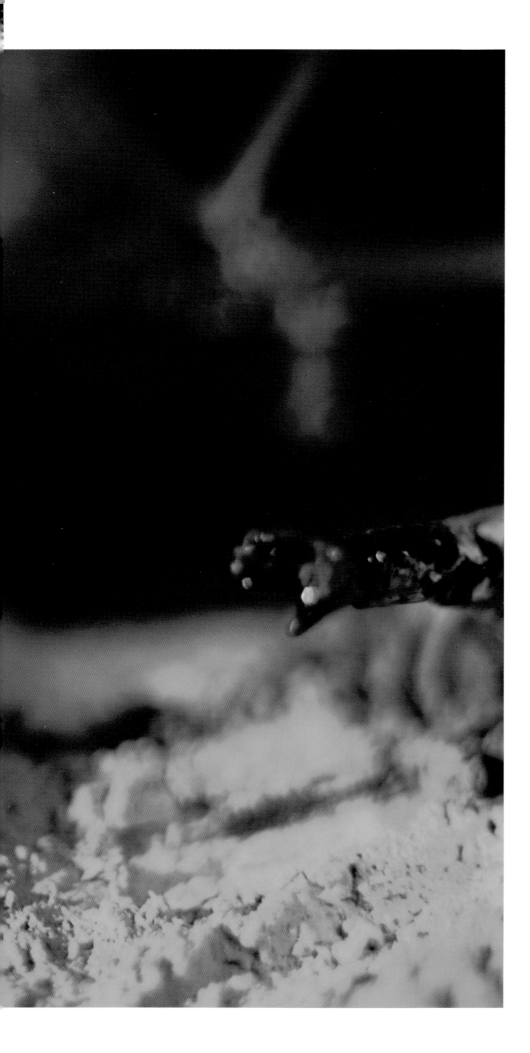

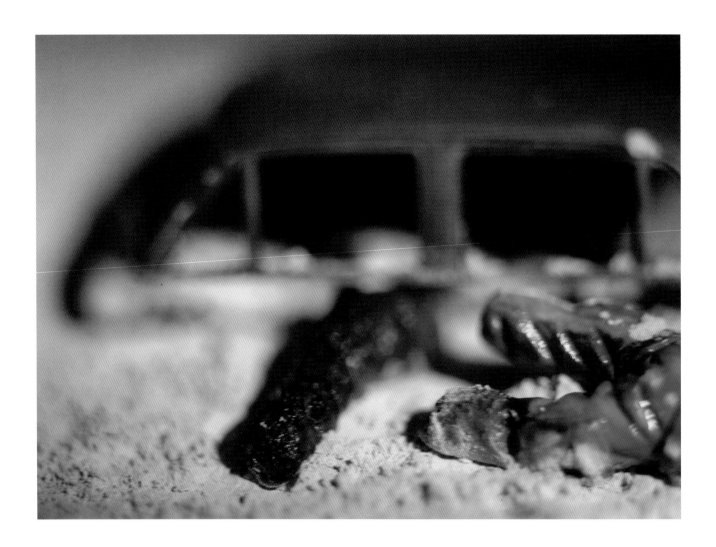

Something dark and twisted comes into view, laying
in the middle of the street, which is dirtier and more
cluttered than usual. It takes a second to figure it
out, and I slowly realize that it is the engine block
to a small car. Beyond it are a few twisted pieces of
metal, apparently the frame of the vehicle. A small
ambulance is just behind the wreckage, and local
people are loading burnt, mangled bodies into it. As
I take in the fact that I am looking at dead people,
a metallic voice in my ear announces that we have
wandered into the scene of a car bomb attack.
Apparently it happened just minutes ago, even though
none of us heard the explosion.

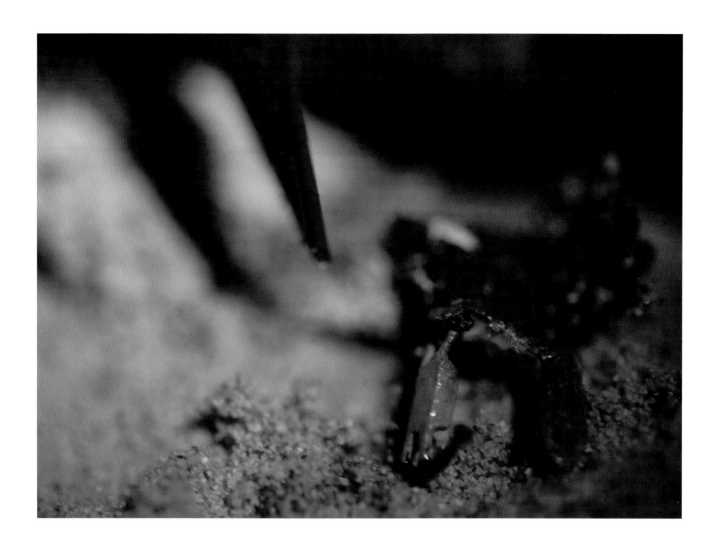

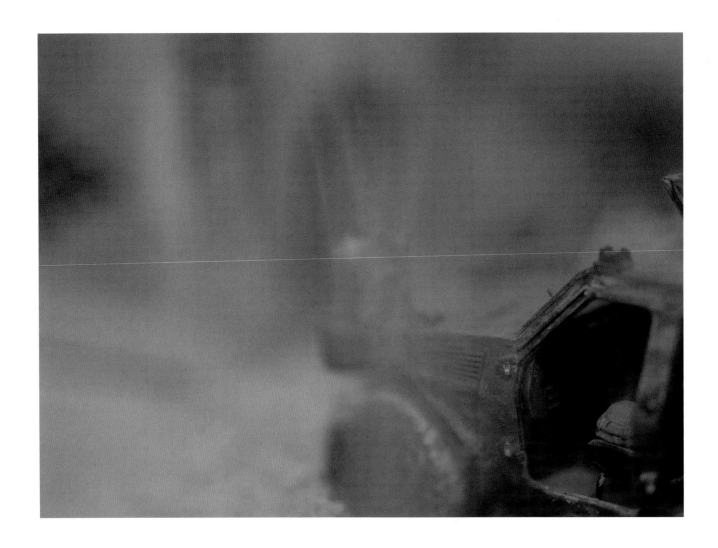

You have to go around big potholes and chunks of concrete blocking part of the lane. It's not a good feeling, because all your training tells you that these are ideal sites for improvised explosive devices. In fact, as we drive past some of them, the boss and SPC T point out things like, "Oh yeah, this is where so and so hit the IED last week." The threat is very real, and you can sense it in the air. You can't think "It won't happen to us," you have to assume it will. Yet we discuss it in the same tone we might talk about last night's football.

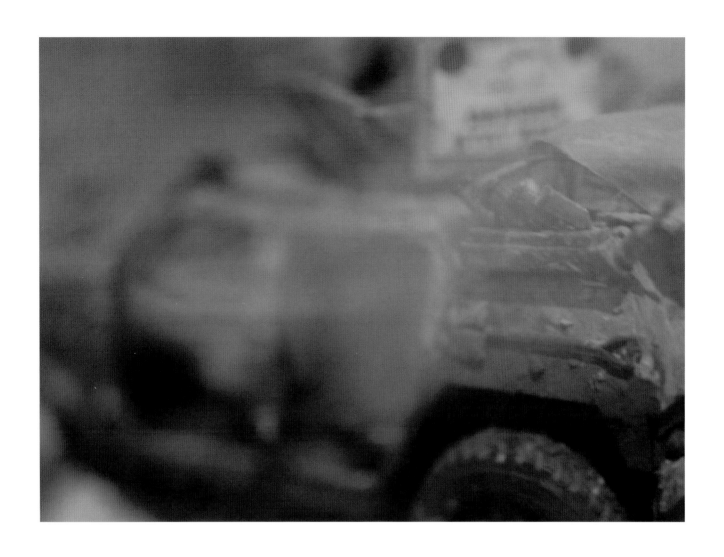

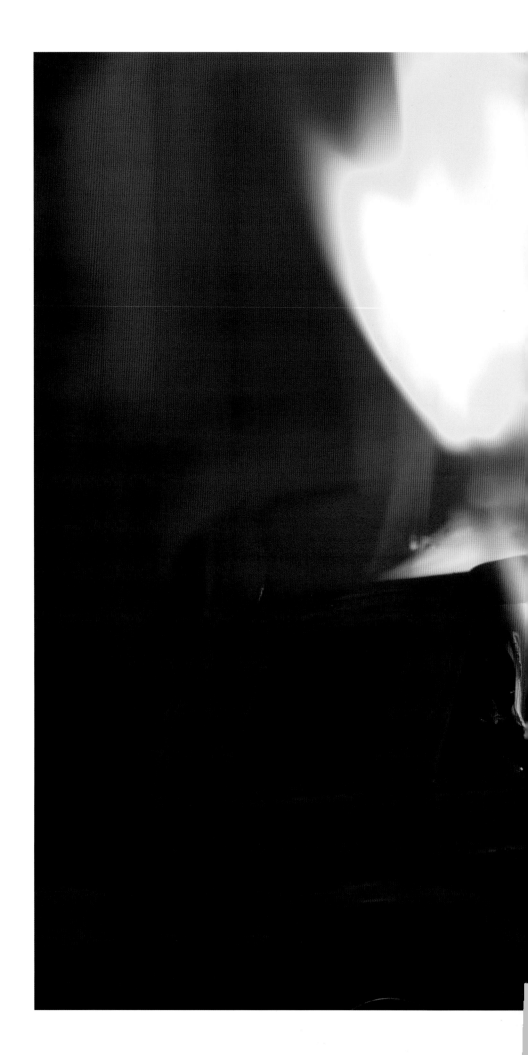

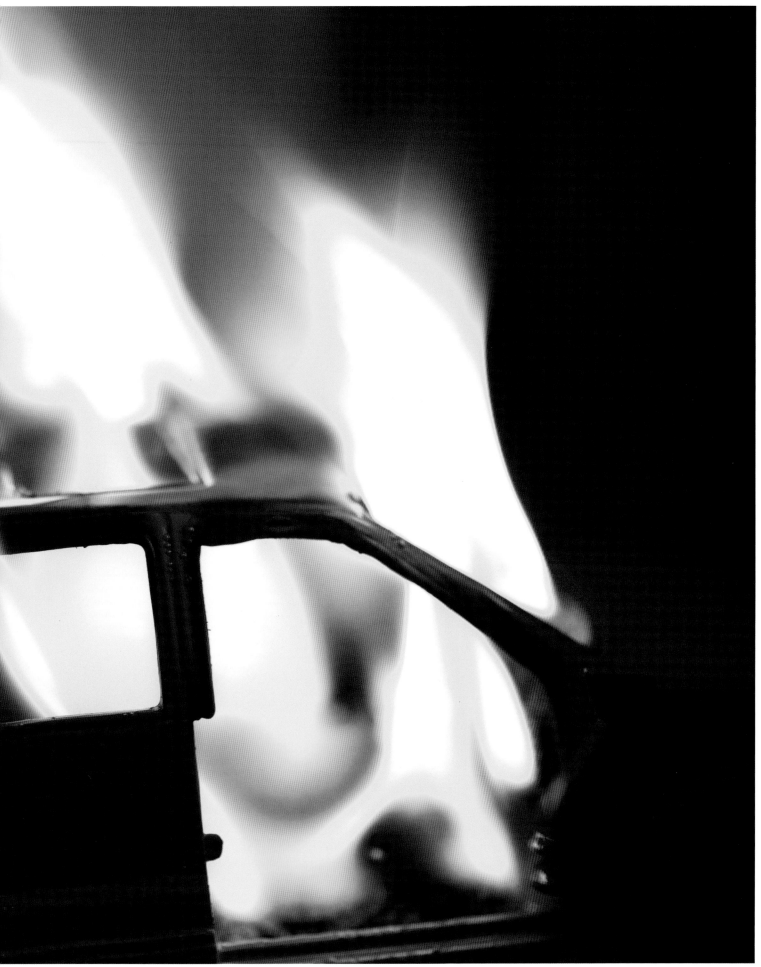

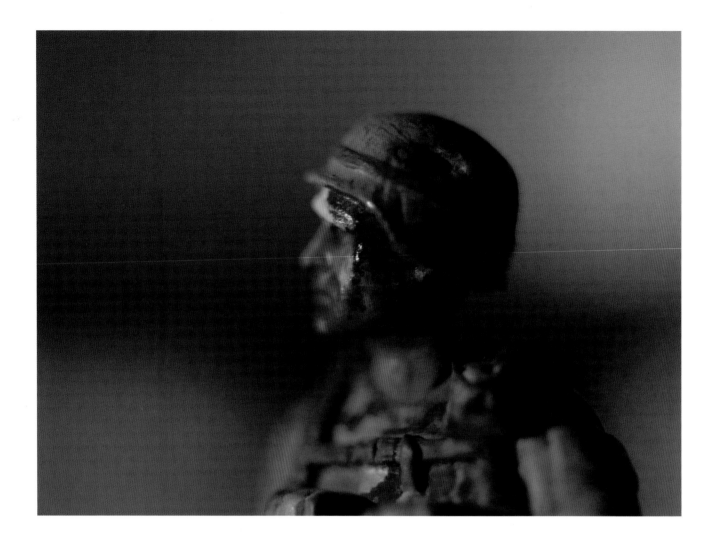

It's interesting to watch people trying to be normal in the aftermath of a fundamentally disturbing event. A few blocks away, corpses were littering the blackened asphalt of a city square, burning. Ambulance crews would be arriving and trying to find the wounded amongst the debris and the dead. But not us. It was someone else's job, and there really wasn't anything to do here but carry on with the mundane details of the still alive. So, we all walked around and fiddled with our gear or stood and tried to make small talk through clenched jaws; but all the voices were a little too loud or a little too quiet, and the people walking by tended to look down at the gravel a little too intently, with the occasional anxious glance towards the shrouded sky, or the perimeter wall that seemed just a little too close.

EMBRACE THE SUCK

In the Sunni Triangle, even though statistically fewer people get killed in combat here than die daily on America's highways, you feel like death is closer, breathing down your neck, taunting you. And you laugh at him. You live and laugh right in his dark foreboding shadow, because what else are you going to do, cry about it? You just focus on the mission, and contribute the best you can.

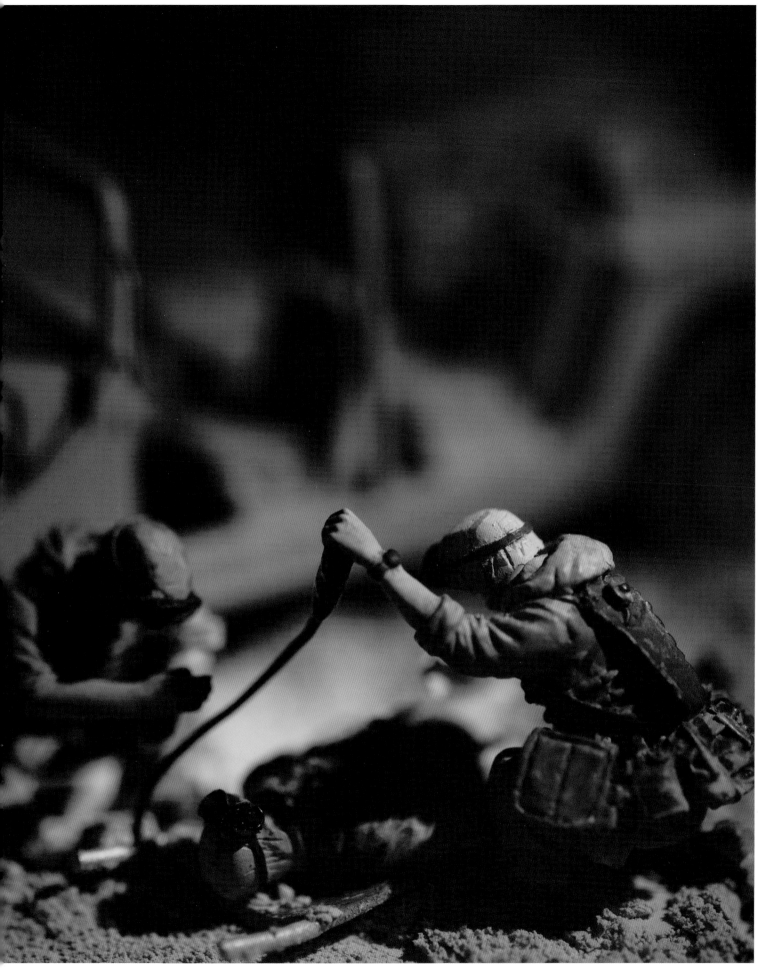

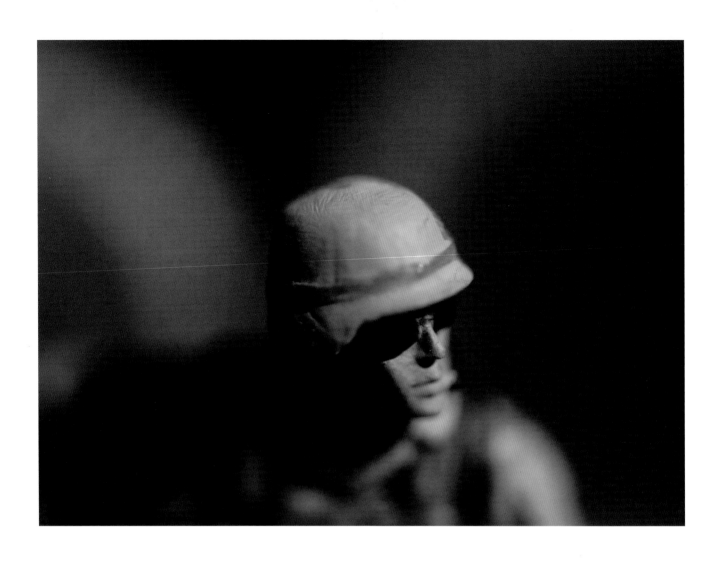

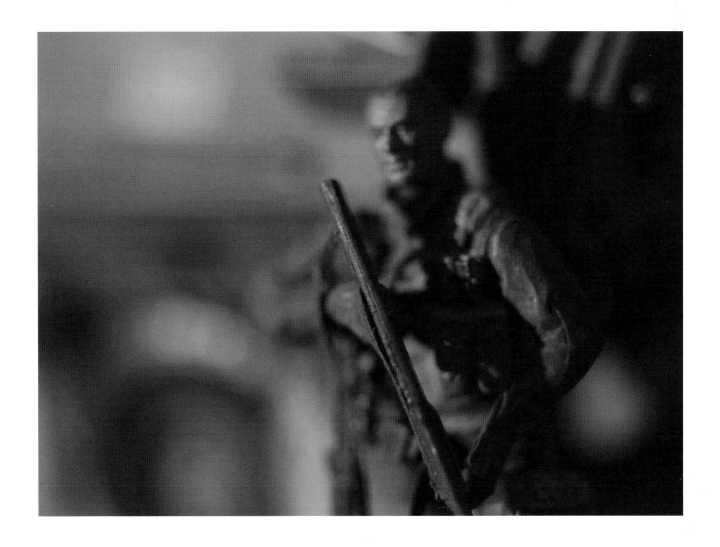

I catch his eyes, only for a moment, and I see everything that I need to see, fear and the look of being lost, as he babbles on about warlords and wiping them out with his AT-4 rocket launcher. I've seen the same look in many Joes, both here and in Iraq, a look of despair entwined with resolve and determination at the same time. "What happens next?" with a side of "I will be going home."

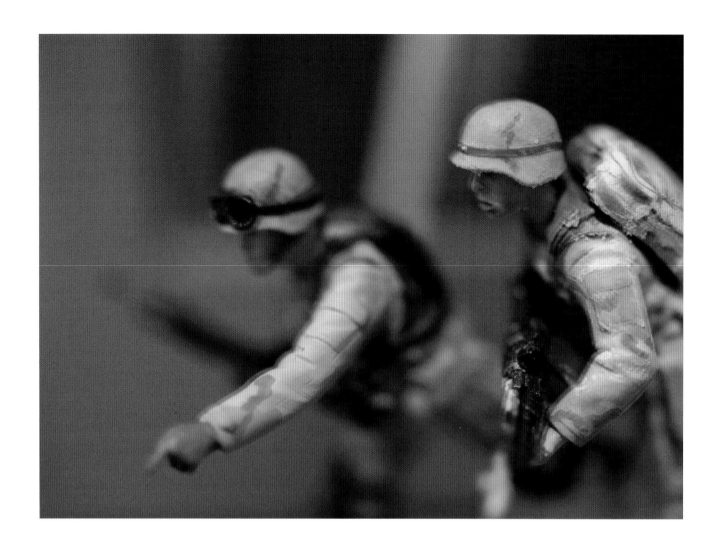

It seems like it's been forever since I lived that "normal" life—the normalcy that I know I'll never quite grasp again. Paradoxically, the last year blends and runs together into one long, blurred day. It doesn't feel like a year. It feels longer and shorter all at the same time. I want to leave, to go home, to take things for granted again. I also can't stand the thought of leaving now, of turning my back on so many things left undone.

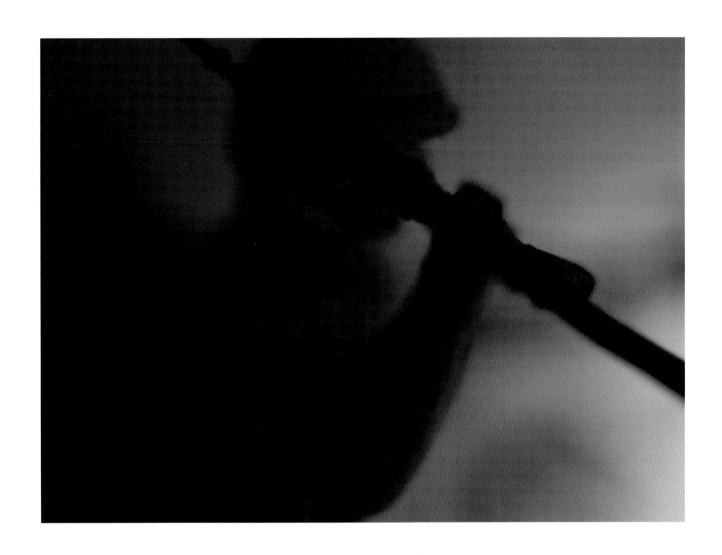

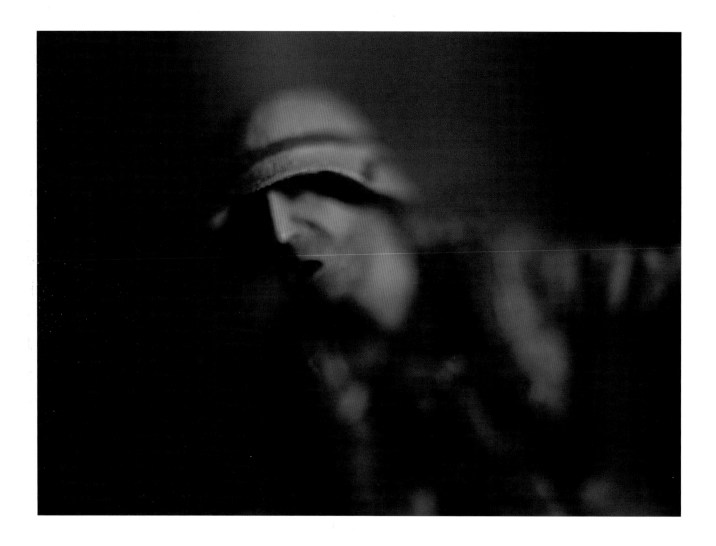

As I was turning my head back to the front and talking to Face, the ANA truck in front of us blew up. It had only been about 10 days since I had one blow up right behind me and kill two ANA soldiers, and now I watched every detail as the one 60 feet ahead of me exploded. I remember seeing parts and pieces fly everywhere. I also remember seeing the flash of the fireball very clearly. Several natural instincts kicked in within milliseconds. First I buckled my knees and dropped down to shield myself from any secondary explosions, direct attack fire, or flying debris. At the same time, I was yelling to Face, "I AM FINE! I AM FINE!" I then popped up and clicked the safety off the MG and started scanning for targets.

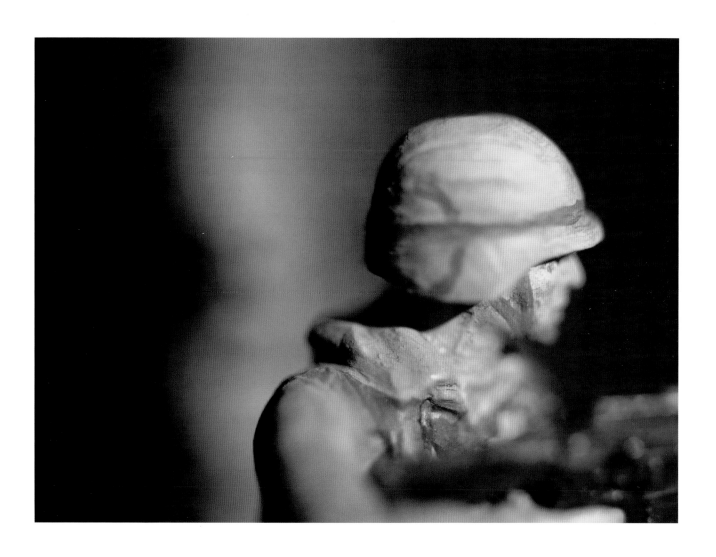

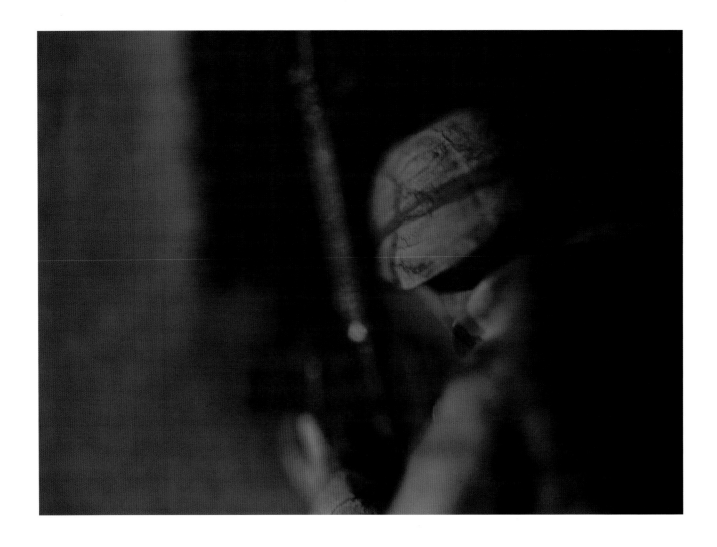

We stop and the ramp drops. I step out and scan
windows and rooftops and nooks and crannies and
everything in between as we all link up and enter a
building. My travel buddy and I take up positions in
the stairwell, not having much to talk about. The sun
shining through a small window dimly lighting up
the stairwell adds to the recurring surreal feeling
I sometimes get. Once again, I can't believe that
I am here.

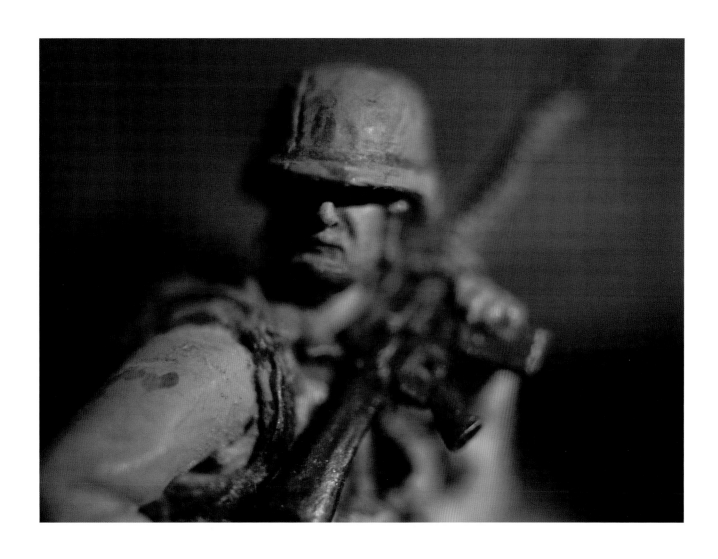

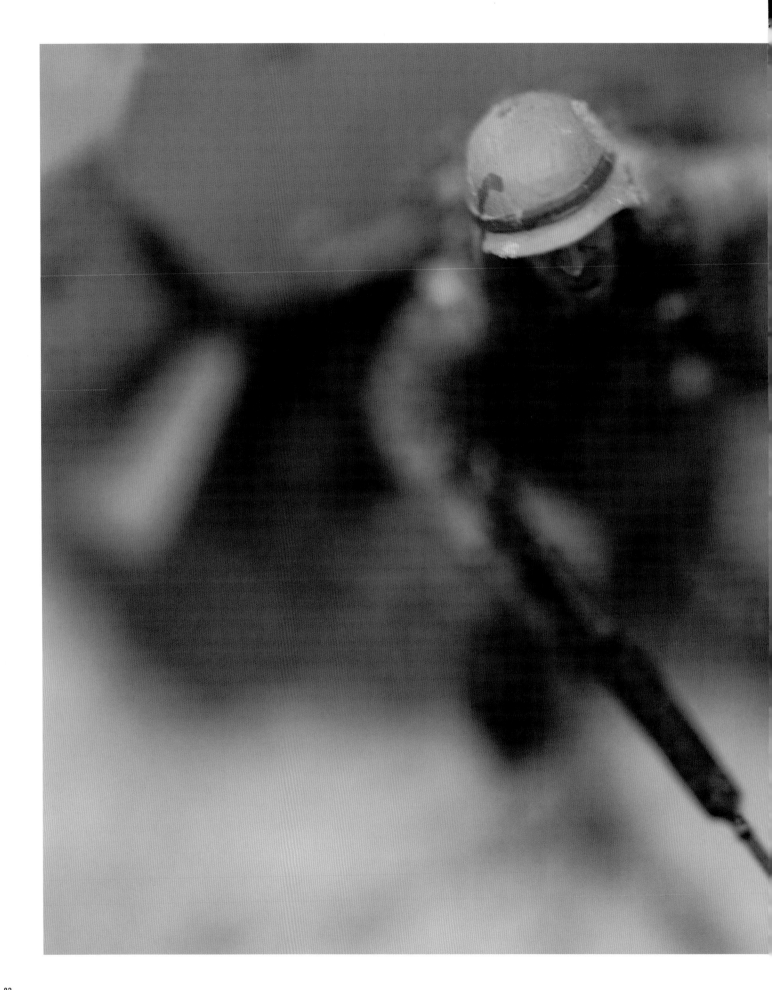

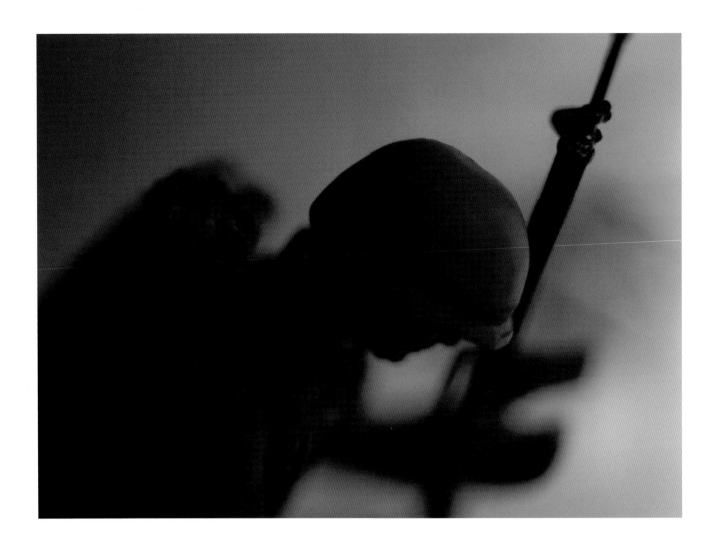

Eons of history surround us, infiltrate us, and turn
to dust beneath our feet. The ashes of countless
cultures, civilizations, and rulers' dreams are in this
earth. With each breath, I inhale a few molecules of
the dying gasp of Cyrus II, the Persian "Constantine
of the East." In the howling wind I can almost hear
the cries of a multitude, dying on killing grounds
across the ages.

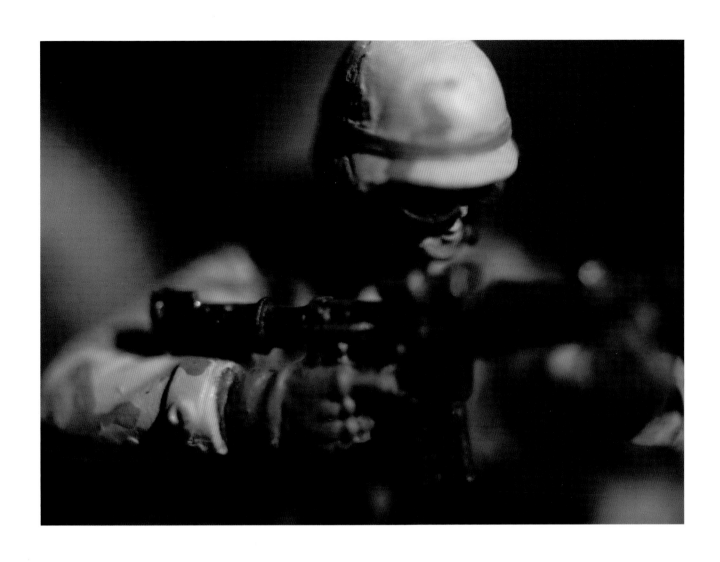

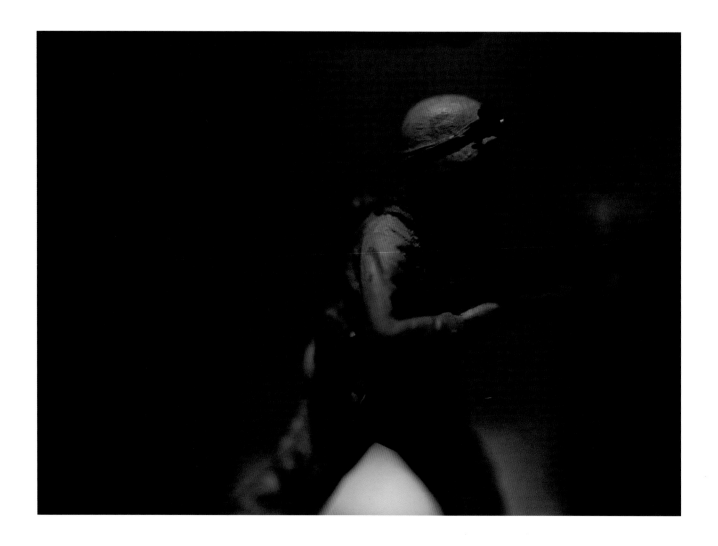

In the distance, I can hear the faint crack-crack of
gunfire, competing with a cheap loudspeaker wailing
an Imam's call to prayer. The sounds are utterly alien,
inherently unfriendly, and yet instantly sum up being
in Iraq—along with the choking punch of the acrid
smoke in the back of my throat, the irritating rasp of
sand in my boots, and the swarmy embrace of sweat-
greased body armor.

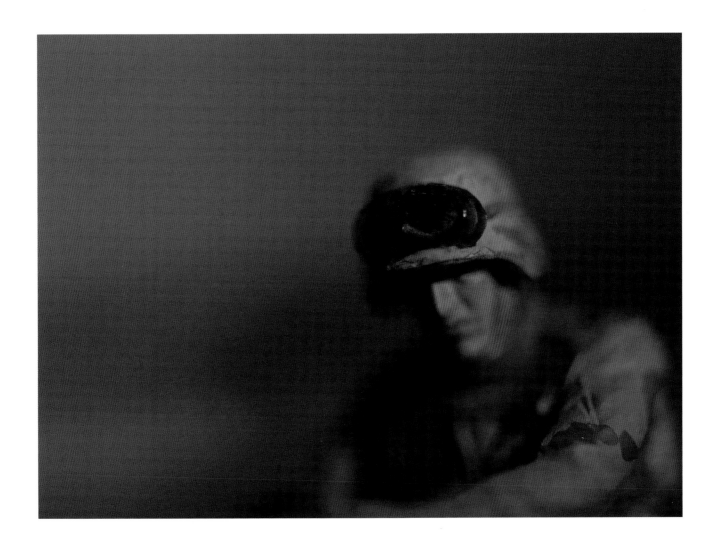

At night, when there's a light breeze, nothing is exploding, and the few trees that encircle my living area sway and make sounds like giant wind chimes, I can find some solace. I can look back at the days, and the weeks, and try to capture them in my journal, lest I forget. Carpe diem. I try to seize the days, even the bad ones, knowing that I have a lot to be thankful for.

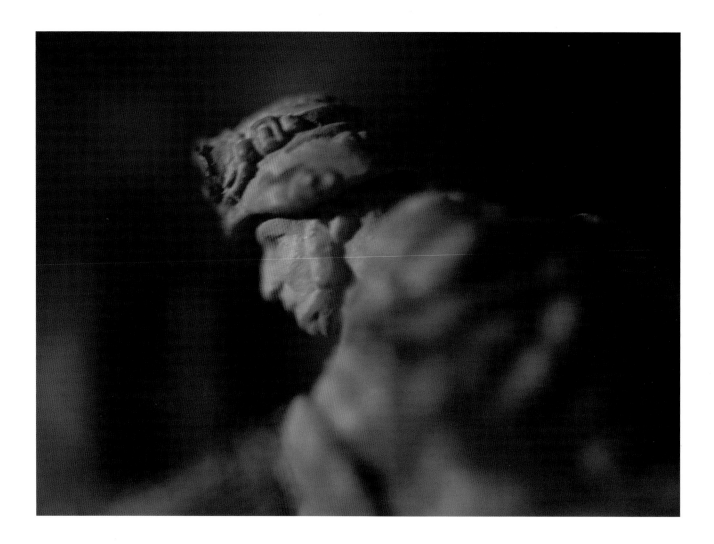

I understand it now. Past whatever you did, whether
it was kicking down doors, patching people up,
answering radios, or whatever, there is a common
understanding of being in the military during
something like that. It's everything involved, and
when I talk to other veterans from WW2, or Vietnam,
there is that understanding that we all share. This is
one of those things that people who haven't served in
a war will never understand.

So while people discuss these wars they should
remember that there is so much more that goes into it,
and just watching the news or a movie does not help
you understand. If you want to know, ask a veteran.

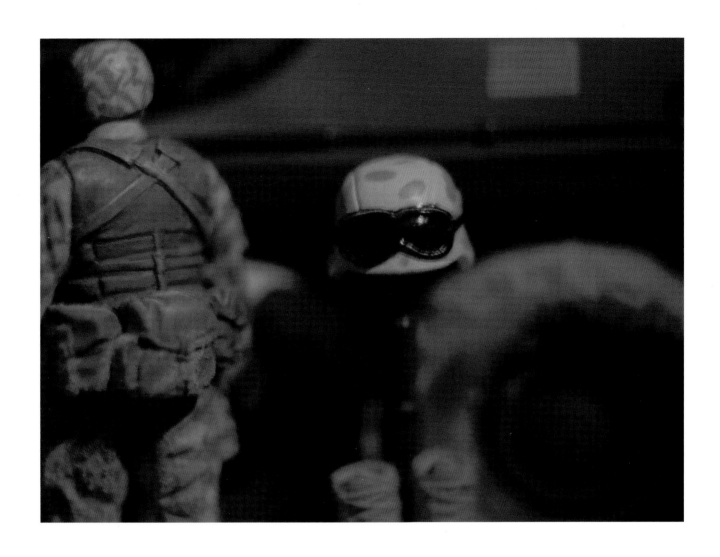

The first-person texts in this book are taken from posts on The Sandbox, an online milblog located at www.gocomics.typepad.com/the_sandbox. The list opposite gives the author, title, and date of the posts, some of which also appeared in *Doonesbury.com's The Sandbox: Dispatches from Troops in Iraq and Afghanistan* (Andrews McMeel, 2007). The author proceeds from the Sandbox book benefited Fisher House, and a contribution to that worthy nonprofit (www.fisherhouse.org) has been made on behalf of *IED: War in Afghanistan and Iraq*.

SANDBOX CREDITS

BIBLIOGRAPHY

Allawi, Ali A. *The Occupation of Iraq: Winning the War, Losing the Peace*. New Haven: Yale University Press, 2007.

Anonymous. *Imperial Hubris: Why the West is Losing the War on Terror*. Washington, DC: Brassey's, Inc., 2004.

Bellavia, David, SSG. *House to House: An Epic Memoir of War*. New York: Free Press, 2007.

Chandrasekaran, Rajiv. *Imperial Life in the Emerald City: Inside Iraq's Green Zone*. New York: Alfred A. Knopf, 2006.

Doonesbury.com and David Stanford, ed; introd. by G.B. Trudeau. *The Sandbox: Dispatches from Troops in Iraq and Afghanistan*. Kansas City: Andrews McMeel Publishing, LLC, 2007.

Fallows, James. *Blind Into Baghdad: America's War in Iraq*. New York: Vintage Books, 2006.

Galbraith, Peter W. *The End of Iraq: How American Incompetence Created a War Without End*. New York: Simon & Schuster, 2006.

Gilbertson, Ashley. *Whiskey Tango Foxtrot: A Photographer's Chronicle of the Iraq War*. Chicago: The University of Chicago Press, 2007.

Gordon, Michael R. and General Bernard E. Trainor. *Cobra II: The Inside Story of the Invasion and Occupation of Iraq*. New York: Pantheon Books, 2006.

Hashim, Ahmed S. *Insurgency and Counter-Insurgency in Iraq*. New York: Cornell University Press, 2006.

Kaplan, Fred. *Daydream Believers: How a Few Grand Ideas Wrecked American Power*. New Jersey: John Wiley & Sons, Inc., 2008.

Keegan, John. *The Iraq War*. New York: Alfred A. Knopf, 2004.

Luttrell, Marcus. *Lone Survivor: The Eyewitness Account of Operation Redwing and the Lost Heroes of SEAL Team 10*. New York: Little Brown and Company, 2007.

Murray, Williamson and Major General Robert H. Scales Jr. *The Iraq War: A Military History*. Cambridge, Massachusetts: Belknap Press of Harvard University, 2005.

Packer, George. *The Assassins' Gate: Americans in Iraq*. New York: Farrar, Straus and Giroux, 2006.

Pritchard, Tim. *Ambush Alley: The Most Extraordinary Battle of The Iraq War*. New York: Presidio Press, 2005.

Ricks, Thomas E. *Fiasco: The American Military Adventure in Iraq*. New York: Penguin Press, 2006.

Rogers, Paul. *Iraq and the War on Terror: Twelve Months of Insurgency 2004/2005*. New York: I.B. Tauris & Co Ltd, 2006.

Tucker, Mike. *Among Warriors in Iraq: True Grit, Special Ops, and Raiding in Mosul and Fallujah*. Guilford, Connecticut: The Lyons Press, 2005.

West, Bing. *No True Glory: A Frontline Account of the Battle for Fallujah*. New York: Bantam Books, 2005.

Woodward, Bob. *State of Denial: Bush at War, Part III*. New York: Simon & Schuster, 2006.

Wright, Evan. *Generation Kill: Devil Dogs, Iceman, Captain America, and the New Face of American War*. New York: Berkley Caliber, 2008.

Zimmerman, Jon Dwight and John D. Gresham. *Beyond Hell and Back: How America's Special Forces Became the World's Greatest Fighting Unit*. New York: St. Martin's Press, 2007.

ACKNOWLEDGEMENTS

A book like this would not have been possible without the support and encouragements of many individuals. First and foremost I want to thank my very good friend and former collaborator Garry Trudeau. When I first started thinking about this book, it was Garry's thoughtful advice that helped me bring focus and direction to the project.

My thanks to all the Sandbox contributors, whose words enriched this project considerably. David Stanford brought his expertise as the editor of the Sandbox milblog to crafting the text for this book.

The plastic model kits of soldiers, tanks, and Humvees that I used for these photographs are commonly available in many hobby shops and online. These simple kits, however, were transformed into miniature works of art by Jeffrey Gutzman of BBG Enterprise Worldwide. Without Jeff's amazing skills and willingness to readily build, paint, and customize these models, none of the work in this book would have been possible.

I.E.D. marks my first venture into the world of digital photography. It is not easy for someone like myself, in the prime of middle age, to "go back to school" and learn new skills. However, thanks to the knowledge and patience of Jeff Hirsch and the staff at FotoCare, and the generous support of Ari Briggs and Kevin Stuts of Leaf, I was able to do so.

I also want to thank Jason Burch, who generously made himself available to help and guide me through any and all technical problems as I entered the digital world. Jason also created all of the final digital files for the production of this book.

My studio manager, Erin Hudak, worked tirelessly to provide assistance whenever and wherever it was needed throughout the course of the project. At the same time she managed to help maintain the modest level of sanity that reigns in my studio.

I want to thank Daniel Power, Craig Cohen, Sara Rosen, and Kiki Bauer and all of the wonderful people at powerHouse Books for their support and faith in this book.

One always saves the best for last. Thanks to my wife, Kate, for lending her photo editing skills, along with her love and support, and our son Sam, who excused me often enough from playing Thomas the Tank Engine so that I could work on and eventually finish this book.

I.E.D.
War in Afghanistan and Iraq

Published in the United States by powerHouse Books,
a division of powerHouse Cultural Entertainment, Inc.
37 Main Street, Brooklyn, NY 11201-1021
telephone 212 604 9074, fax 212 366 5247
e-mail: ied@powerHouseBooks.com
website: www.powerHouseBooks.com

First edition, 2009

Library of Congress Control Number: 2009920526

Hardcover ISBN 978-1-57687-488-2

Printing and binding by Pimlico Book International, Hong Kong

Text edited by David Stanford

Typesetting by Kiki Bauer

A complete catalog of powerHouse Books and Limited Editions is available upon request; please call, write, or visit our website.

10 9 8 7 6 5 4 3 2 1

Printed and bound in China